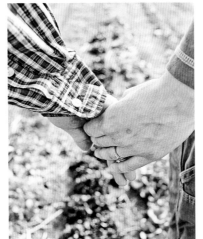

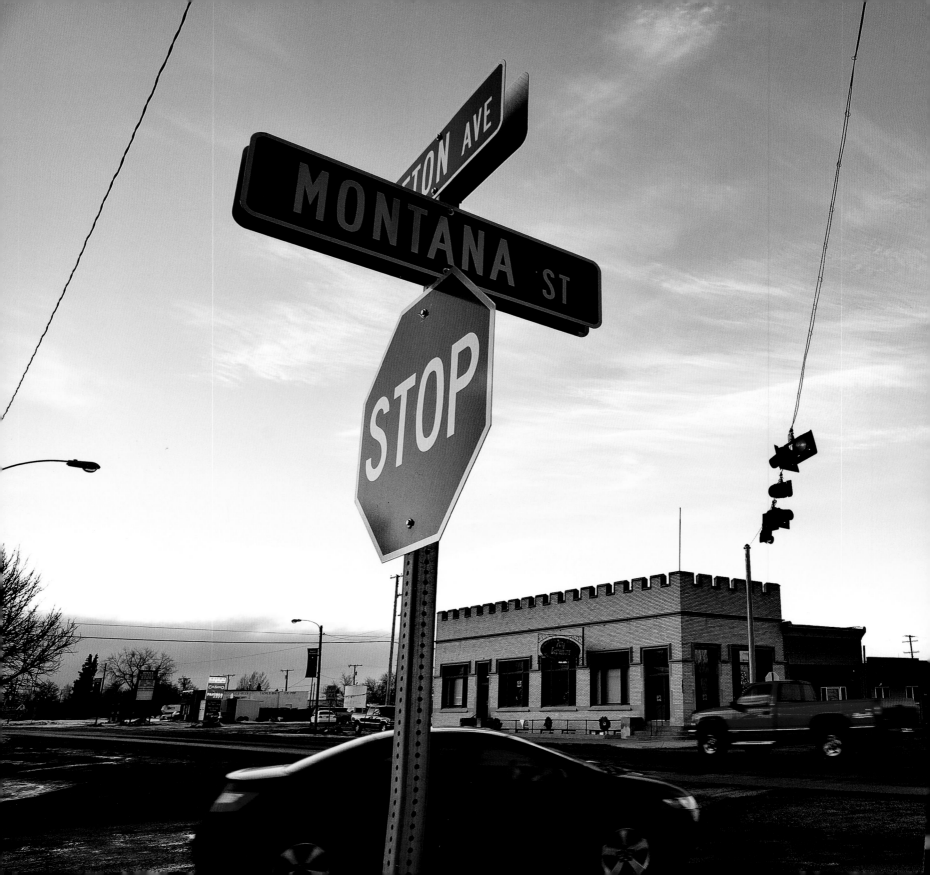

Montana

REAL PLACE, REAL PEOPLE

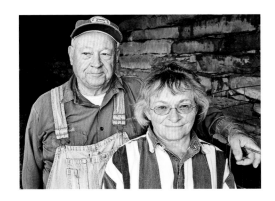

Essays by
ALAN S. KESSELHEIM

Photographs by
THOMAS LEE

COMPANION PRESS
Bozeman, Montana

real /riəl/ ʟME A *adj.* **II4** That is actually and truly such; that is properly so called; genuine; natural, not artificial or depicted; actually present, not merely apparent. **6†a** Sincere, straightforward, honest; loyal, true. **b** Free from nonsense, affectation, or pretence; aware of or in touch with real life.

Companion Press
Bozeman, Montana
Jane Freeburg, Publisher/Editor
www.companionpress.biz

Design Consultant: Don French
Printed in China through
Bolton Associates, San Rafael, California

Library of Congress Control Number: 2011939961

ISBN 978-0-944197-88-2 paperback
ISBN 978-0-944197-89-9 slipcased cloth limited edition

First Printing, 2012

Acknowledgments

Heartfelt thanks to Big Sky Publishing and the staff of *Montana Quarterly* magazine, especially Nick Ehli and Megan Regnerus, for their editorial vision, insight and the permission to use many of these photographs. The essays and many of the photographs in *Montana: Real Place, Real People* originally appeared, in slightly different form, in either *Montana Quarterly* or *Big Sky Journal.*
 –AK *&*TL

Contents

Braiding Word and Image..........7
FOREWORD

Golden Valley Rider..........8
CONNECTING THE BOXES IN RURAL MONTANA

Lose-Lose..........16
THE STRANGE & REMARKABLE CASE OF
FRANK DRYMAN

Genuine..........25
PHOTOGRAPHS

Bittersweet Prairie..........36
HEARTACHE FOR PLACE

The Cake Ladies..........44
HOLDING HISTORY ALONG THE YELLOWSTONE

From Dirt to Fuel Tank..........52
KEEPING ECONOMY CLOSE TO HOME

The Serial Art of Jerry Cornelia..........58
RED-HAIRED WOMEN, NO EYES & TRUE HORSES

Whispers in the Wind..........64
UNSOLVED TRAGEDIES IN THE HIGH PEAKS

Character..........71
PHOTOGRAPHS

A Dangerous Woman..........82
100 YEARS OF RABBLE-ROUSING

Blade Master..........90
CHILD PRODIGY COMES OF AGE

Not Letting it Die..........96
A FARMER'S DEDICATION TO NATURE

Tending the Spiritual Flame..........104
BOB STAFFANSON'S AMERICAN INDIAN INSTITUTE

Redemption..........112
OUT OF THE ASHES

From top: 85-year-old Wanda Hale reads some Valier history; one friend comforts another during a dominoes game in Rapelje; farmers keep track of who has to pay for coffee at the Kountry Korner Cafe near Bozeman.

Opposite:
Wylie Gustafson, musician and horse trainer in Conrad.

Preceeding pages:
Montana Street and Teton Avenue, Valier.
Russell and Maureen Curtiss, Circle.

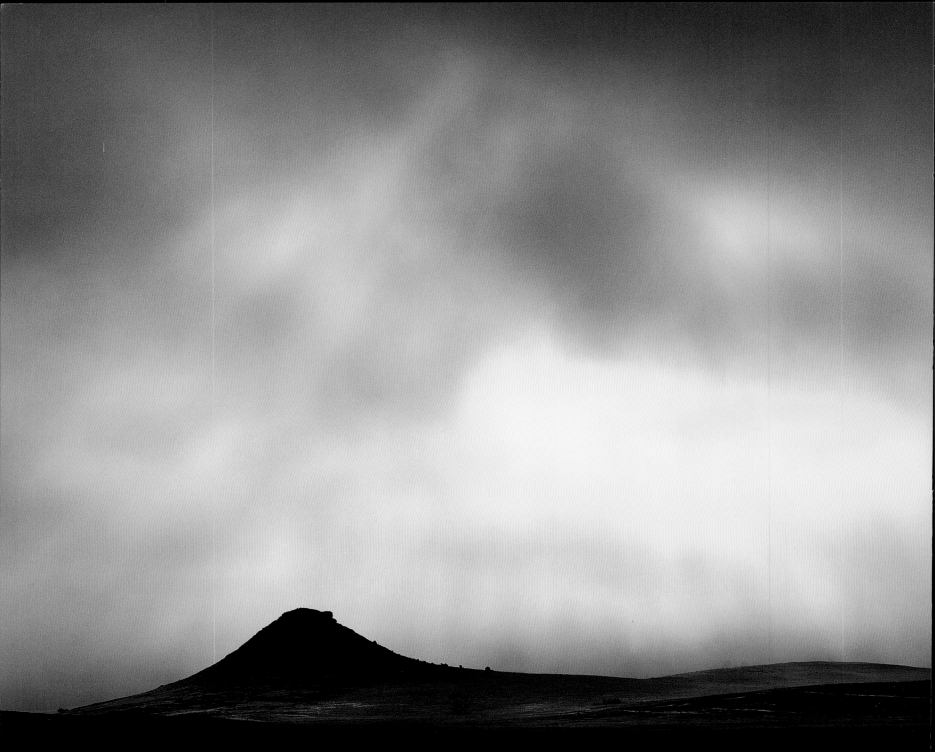

Braiding Word and Image

FOREWORD

*T*he stories, they lie around everywhere, waiting to be picked up and revealed. They litter the landscape, especially this landscape—stories in Montana are woven in with this sweeping, ambitious, hardscrabble place. They can come from anywhere. A fifty-word snippet in the newspaper about a man picking up an old boot below Granite Peak leads to *Whispers in the Wind*. My knock on a farmhouse door upstream of Park City, inquiring about scattering the ashes of my uncle along the Yellowstone River, leads to *The Cake Ladies*. One night my brother-in-law mentions that he heard Montana had the longest rural postal route in the country. There's a story, I think. Turns out he was wrong. Montana doesn't have the longest route, but it does have some truly rural and often gnarly routes. His off-hand comment leads to *Golden Valley Rider*. I sit on a bus next to a woman near Polson. We get talking. I mention that I am a writer. "You should check out my son," she says. "He's done some pretty amazing stuff." Yeah, sure, I think. I do check out her son, and it brings me *Blade Master*.

None of the people in this collection are celebrities. None of them are what you'd call famous, except in a parochial sense. They are genuine, passionate, and in their way, heroic people, living quiet, remarkable lives in our midst, under the big sky. And because of that, they are also inspirational.

So the stories come to us. Thomas and I go out with camera and notebook to see what's there. Some days we drive from Bozeman to Sidney and back, a fourteen-hour round trip, for a story. Or to Miles City, Glendive, Dillon, Frenchtown, Deer Lodge. We interview people in cafes, in their living rooms, over lunch, in corrals, in prison parole-hearing rooms, along riverbanks. We watch them feed chickens, jump irrigation canals, pet their dogs, make food, look at pictures, plant gardens, forge steel, sort mail, read the Bible. Mostly, for both of us, we wait; for that crystalline moment, that revelatory scene or image that makes the whole. When Jerry Cornelia steps off of his back porch and nuzzles up with one of his horses. When Tia Kober pauses over the kitchen sink to gaze out at Youngs Point, looming over the Yellowstone River, where William Clark stopped to camp in July of 1806. That moment when Thomas catches Elsie Fox tapping her hand on the four-hundred-page FBI dossier with her name on it, or he gets Frank Dryman gesturing his hands with the tattoo that led to his recapture in Arizona.

"I look for that moment when their humanity is visible," Thomas says. "When you see the human being inside in a gesture or an expression."

Sometimes we recognize that moment. Bingo, we think. With other stories, it's only later that we realize that when Richard Stewart talked about the juniper tree he sat next to for solace, it is the metaphor the story has to hang on. Or that when Robin Puckett gets out of her truck halfway up a slippery hill and punches her pen into an electrical connection under the dash to make it start up again, it sums things up.

The elegance is the melding of those photographs and those words, the "bingo" moments each of us brings to the table, which create something greater than the sum of its parts. How that happens is largely a mystery. That it happens is the magic of a duet.

–Alan S. Kesselheim
Bozeman, Montana
Autumn 2011

Fog lifts over a butte near Broadus on a spring morning.

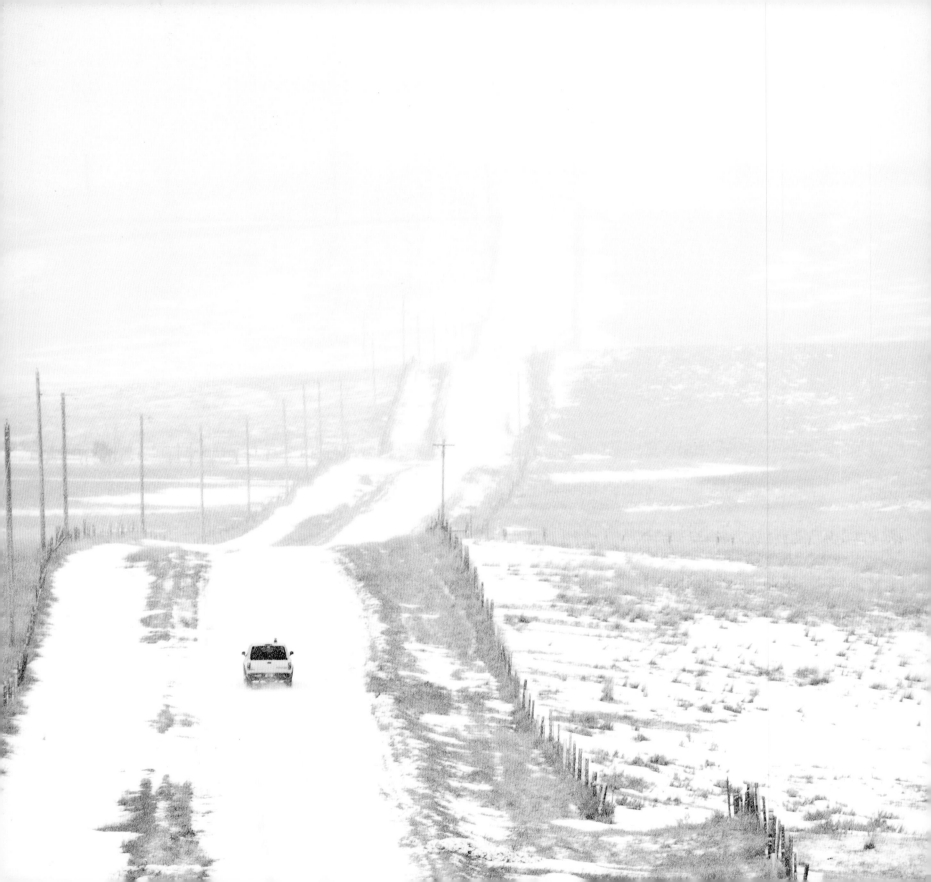

Golden Valley Rider

CONNECTING THE BOXES IN RURAL MONTANA

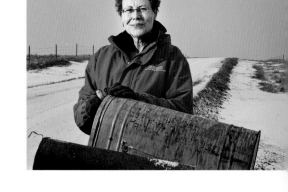

A few miles south of Ryegate, Robin Puckett pulls her small Mazda pickup abreast of a row of mailboxes. The sky is leaden gray, brooding with a coming storm. A woman is standing in the lee of another pickup, exhaust pluming into the cold morning air. She wears a winter coat, her head tucked away from the wind, waiting. Puckett idles forward. The woman walks to the open window, leans in to the warmth of the cab. Robin hands her the mail. They exchange good mornings, wonder about the storm—when and how bad—before she returns to her truck.

"People meet me at the boxes a lot," Puckett says. "It can be a four- or five-mile trip from the house for some. They'll give me money for postage. Sometimes they'll call ahead and have me bring them a priority mailer or some stamps."

"I suppose there is the human contact, too," she adds, watching the truck pull away down a long, empty dirt road.

Puckett has driven the Ryegate highway contract route for twenty-eight years, since the early 1980s. Six days a week on the southern loop, three days a week up north toward the Big Snowy Mountains. If all goes well, she can do both routes in five hours. Today

looks like five hours will be a hard target. This is Musselshell River country—Fish Creek, Rock Creek, Big Coulee Creek, Locomotive Butte, the bigger part of Golden Valley County. It is a place where antelope and mule deer outnumber people and cattle by a long shot. Roads are more dirt than paved. Wind drifts snow in the hollows and rain turns hills into gumbo challenges; a place where, as Puckett says, "If you have to walk, it's miles and miles and miles to the nearest house."

Best to be self-sufficient. She carries candles, matches, water, energy food, sleeping bag, spare boots, a snow shovel. Before cell phones she had a ham radio in the vehicle, and her license plate remains her call sign— N7RLS. She wears her hair short, tightly curled, and has the practical air of someone used to figuring her way out of jams. "I can change out a flat in under ten minutes," she claims. "I've learned a lot about fixing things on cars. I believe I'm on my sixth vehicle since I got the route. And this one, I hate to say, is a piece of crap."

Unless it's twenty below or colder, she drives with the passenger window wide open and the heat blasting on high. "I was blessed with long arms," she says, reaching across the truck cab and out the passenger

Robin Puckett drives the dirt roads of Ryegate's rural postal route.

side to feed mail into the next box. Although she has already "cased" the mail in order of delivery and laid it out in the metal tray she inherited from the last driver, almost three decades earlier, she rechecks every bundle before it goes out the window.

"Don't like mistakes," she says.

What becomes clear, despite the miles between houses and the horizons of sagebrush and yucca and brown stubble that dominate the view, is that Puckett's route is an erratic, wandering thread stitching together an austere and far-flung community, and that she is continuing a history of human connections across land where loneliness is the norm.

She is the latest in a string of mail carriers going back over the past century. Betty Kunesh, now almost ninety years old, served as Robin's substitute driver for many years. Kunesh has spent her entire life in Golden Valley County, growing up in the upper Big Coulee and later moving closer to Ryegate. She remembers all the drivers back to the early 1900s, including her mother-in-law, who substituted for Elza "Dee" Iden, before the Depression. Iden's contract stipulated that he would have to travel three miles through pasture-land along the route. He delivered the mail with a Whippet car and was famous for never wearing a hat, and for planting flowers by mailboxes.

"He wore a buffalo robe and nothing on his head," Kunesh remembers. "Back then, when the roads got really bad, they delivered the mail by horse and sled. They would stay over at someone's house in the Big Coulee and take two days to do the route. We rode horses a lot back then."

Mailboxes are still miles apart. Often as not, the house attached to the box is out of sight down a two-track lane. Puckett's truck coming past is a faint heartbeat reaching out from town and the world beyond.

Herds of antelope look up from grazing, trot away through the sage. Rough-legged hawks rise off of fence posts. Narrow coulees scribe deeply into the bedrock valley bottom. Even on this cloud-bound day, the country is vast and exposed, shouldering away against the horizon. The weathered ruins of old homesteads settle into the landscape. She drives past the abandoned, one-room 79 School where she and her husband used to go to community dances. Rusted wagons and machinery punctuate empty fields. Buildings stand out, stark topographic features under scudding clouds.

It takes a certain personality to embrace this country, a person whose heart swells in the face of long distances, who is exhilarated rather than daunted in the middle of nowhere with a storm coming on. "I love the spring most," Puckett says. "It's so green everywhere. All the baby animals are out. The bluebirds and meadowlarks sing from the fence posts. Wildflowers color the fields. But there's beauty in the winter too." She points up to the distant rimrock that

bowls the skyline above Big Coulee. "When the wind drives snow over the lip of rocks, it's like a waterfall coming off." It also means that there are likely to be drifts to deal with along the more remote and exposed roads.

Over the years Puckett has refined her backcountry driving technique. "I used to blast through snow drifts," she confesses. "Problem is, if you don't make it, you're high-centered in the middle and you have some serious digging on your hands. And sometimes the wind is drifting it back in as fast as you shovel it out. I've become a confirmed creeper when it comes to snowdrifts. I'll just probe my way in, not too fast, so I can back out again and escape if I have to. Same goes for mud. Unless it's a pretty short stretch, I don't blast through anymore."

More important, she has figured out the alternate routes to avoid bad spots. She knows where to expect mud holes, where the snowdrifts pack in two feet deep, the hills where trucks slither sideways. She knows the secondary roads, the two-tracks through pasture that aren't on any maps, but that will get her around a flooded bridge along Fish Creek or avoid the bad hill with a ninety-degree turn at the bottom.

Early in the route, past the Hutterite colony with its cute, red box, Puckett delivers to a house that is regularly blocked by blowing snowdrifts.

"If it's bad, he opens up a gate to his pasture for me," she says. "He marks out a route through his fields so I can come up from behind and get to the box.

Some years it's the only way to get to him for weeks."

The mailboxes along Puckett's route are as varied and idiosyncratic as the people. Many are mounted on platforms made out of old wagon wheels. A few sport the perforations of target practice. Some of the door hinges have rusted away, and Puckett has developed her two-hand techniques to get them closed. Another one, abandoned, with the door hanging, has succumbed to a second purpose in life as a bird's nest. She opens one with the flag up and letters waiting in a plastic bag.

"Not all of the boxes are waterproof," she explains, as she extricates the sheaf of letters and sets the bag back in.

At the top of a long hill that climbs out of Big Coulee, with a view back toward Locomotive Butte, Puckett pulls into a driveway and turns off the engine.

"I have some certified letters that need signatures," she explains. She reaches behind the seat and pulls out a handful of dog treats. "And I get to visit some of my favorite puppies."

Three dogs spill out of the doorway and come wagging up to her. She wades through them, dispensing treats, loving them up, trying to keep the mail clear of the melee. She could have had these folks come to the post office to sign their letters. Technically, she never has to leave her vehicle, but there is more than a business transaction going on here. There is warmth in the greetings, friendship and company in the middle of empty miles, that heartbeat of connection surging up strong.

By the time she backs out of the drive, it is snowing. At a T intersection on a high point, she extols the view, today shortened to a quarter mile.

"I've taken so many pictures from here," she says. "On a clear day you can see the Snowies to the north, the Crazies to the west, the Beartooths to the south."

Today she drives on. The wind is picking up snow; it writhes across the roads. A faint urgency takes hold. "Long as I can make out the fence line, I keep going," she says.

Repeatedly, when she stops, she has to turn off the ignition and restart the truck in order to get it into first gear. Puckett mutters at the vehicle. Then, on a steep, icy hill, the truck dies and won't start again. She cranks the engine, but it won't take hold.

"This happened once before," she says, pulling on the emergency brake. "I need a pen." She rummages in the glove box until she finds an old ballpoint, gets out and walks around the vehicle. Halfway up a frozen hill, far from anything remotely like help, the sense of exposure is a cold embrace. From the passenger side she leans under the dash and rummages through the wires. "There it is," she says, and pushes at a connection with the end of the pen. Sure enough, when she tries again the truck fires up. She jams it into gear and grannies up the incline.

"I don't even remember how I figured that out," she shakes her head.

There are a great many regulations Puckett is supposed to abide by as a contract mail carrier. Out here, and especially on days like this, the force of those rules is as distant as the nearest mechanic. It is against the rules, for example, to leave anything other than mail in a box. That doesn't stop people from surprising Puckett with tins of Christmas cookies, or her from accepting the seasonal gesture. She is not obliged to leave the set roads of her route, but if she has to get around a flooded coulee, she'll find a way.

"Actually, I'm never supposed to 'dismount' from my vehicle," Puckett says. "I've had carriers I meet at conferences get all huffy when I tell them I get out to deliver mail. But hell, sometimes I've got a mud hole I'm not about to cross to get to a box fifty feet away. What am I supposed to do, turn around? How crazy is that? I'm going to get out, walk around, and deliver that mail. If that's a problem, I guess they'll have to fire me."

Late in the morning, snow falling thickly, Puckett "tiptoes" down a grade and back across the Musselshell into the old settlement of Barber. Like so much of this country, Barber is a shadow of what it was during the homestead era, when hundreds of people lived here, when churches, stores and schools flourished. Now it is a near ghost town, a few house lights still on along the highway.

Puckett regains pavement for a few miles, back to Ryegate, itself reduced to a couple of grain elevators, a cafe, county offices, a few shops and homes, and the post office. She heads in the back door of the small building and picks up the northern packet of mail, sets it in her tray. The building is quiet and empty. Colleen Smith, the Postmaster who has split her career between the Shawmut and Ryegate offices, is away on her lunch hour. Puckett is running late. She has already called ahead to a few people she knows will be waiting for her at their boxes to tell them she's been delayed by the storm. Puckett's lunch hour will be spent in the cab of her truck, nibbling on snacks, heading north into the maw of white and wind under the pulsing light mounted on the truck cab.

Four miles north of Ryegate, a highway sign announces the end of pavement. Snow is spuming across the road like wave foam. The fence posts are visible, but the snowplows haven't gotten out ahead of her. She points toward the Snowy Range, toward people waiting in the wan heat of truck cabs for her. Her yellow light is visible for a hundred yards, a rhythmic beat against the gray swirl, then the storm swallows her.

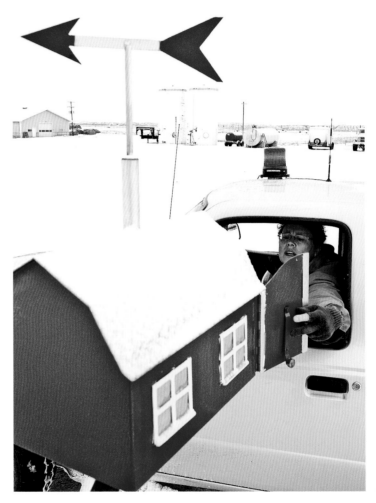

"I was blessed with long arms," says Puckett.

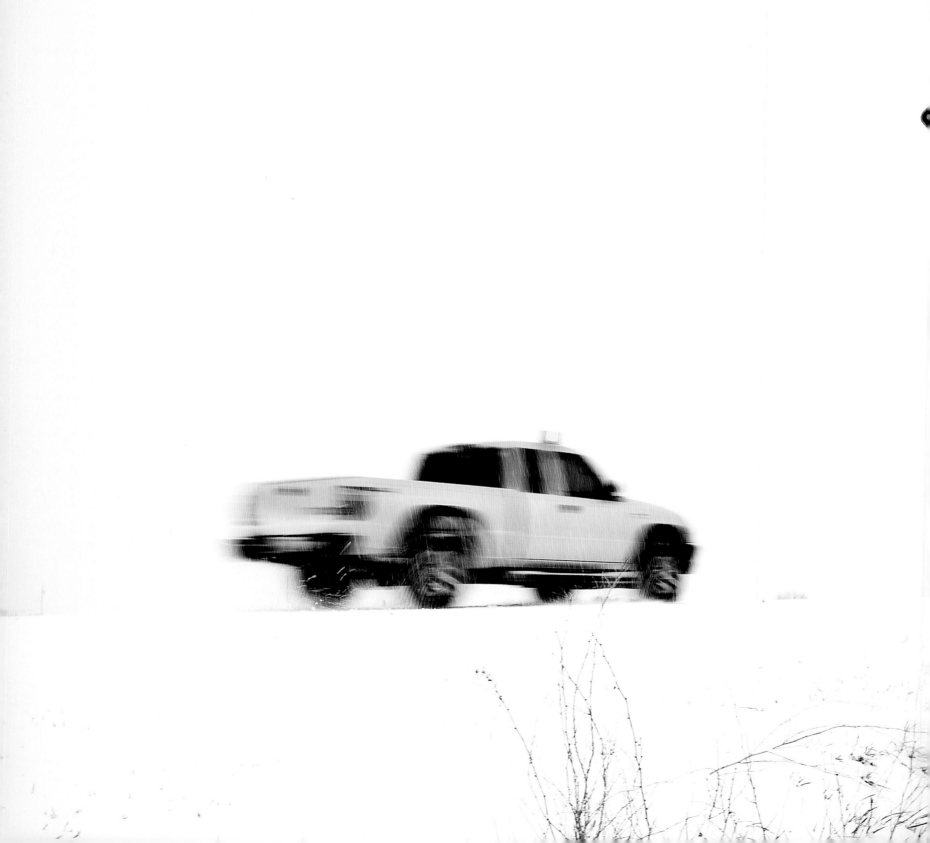

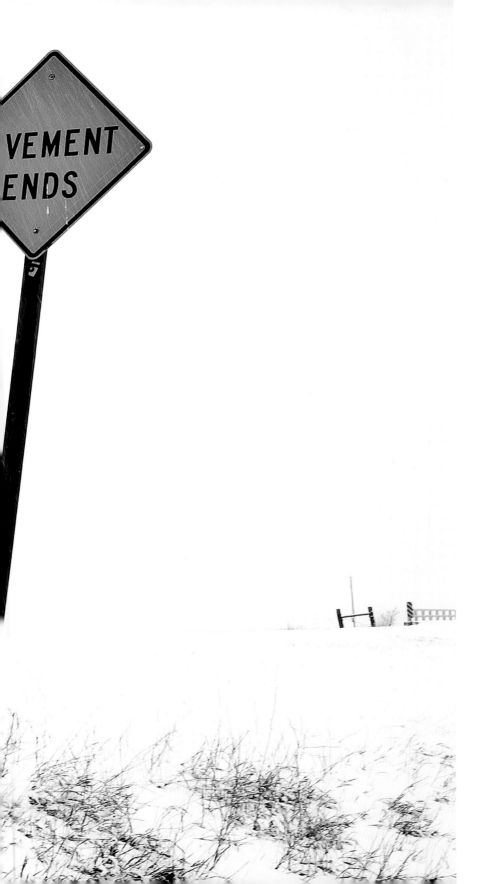

Left: Puckett says it generally takes her about five hours to drive the entire Ryegate postal route. Most of the miles are not paved.

Above: Breaking stereotypes, Puckett says she gets along well with the dogs on her route. And the treats she carries may help, even with the great Dane "that doesn't like men."

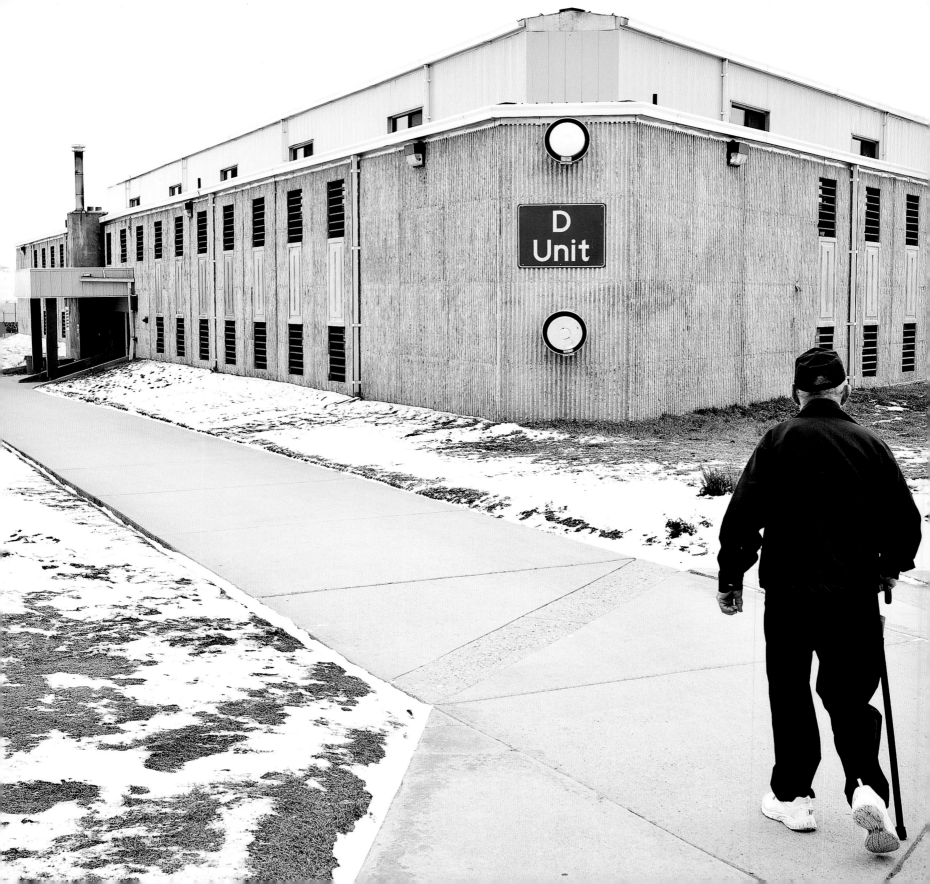

Lose-Lose

THE STRANGE & REMARKABLE CASE OF FRANK DRYMAN

*H*e comes across the empty prison yard with his "Seeing-Eye Cellie" at his side. The winter day is hazy, full of wind. Ravens circle overhead. He wears standard blue scrubs. He is almost eighty years old, legally blind. He uses a cane, but walks at a strong, steady rate, doesn't appear to need his human guide. Inside the parole hearing room he removes his hat; a short brush of gray hair. His gaze is penetrating, despite his blurry vision. He has that air of agitation common to prison inmates, that pent-up buzz—too much time to fret and not enough opportunity to vent. He holds a worn envelope in his hand, a piece of evidence. It is a letter from an acquaintance in Arizona City, where Dryman spent the past forty years as a free man. It extols his virtues as a community member, volunteer, and citizen of good standing.

Dryman has a few things he needs to get off his chest.

He starts in on some technicalities. The fact that the authorities changed his prison number when he was returned to jail after his four-decade escape. The confusion over his name, which one he was going by when he was charged, which one they referred to him by at his parole hearing. He mentions another letter, written by retired Prosecuting Attorney John McKeon, who worked Dryman's murder case sixty years ago. McKeon references Dryman's award-winning conduct as a prisoner and the evidence of his rehabilitation. He pleads for leniency from the parole board.

"They wouldn't allow the letter at the hearing," Dryman says. "The family was allowed all their statements, but they wouldn't hear my letter." He is animated even as he sits. His hands move emphatically, making his points, blurred tattoos on his knuckles, the same tattoos that the private detective who tracked him down in Arizona identified him by. Tattoos which once spelled L-O-V-E.

"Would you believe," Dryman pushes on, with a rueful chuckle that exposes a wide gap of missing teeth. "They gave me a sentence for 'Natural Life'. There is no such sentence."

This much is clear: On April 4, 1951, a man named Clarence Pellett picked up a nineteen-year-old hitchhiker at the 49er Drive-In near Shelby.

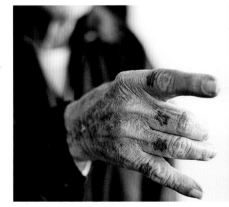

Frank Dryman, legally blind, makes his way to his new home, D Unit at the Montana State Prison in Deer Lodge.

Pellett was an oil field worker and the father of five children. The hitchhiker went by Frank R. Valentine. Something happened in that car. Valentine had a loaded gun and shot Pellett dead, stole the car, and headed for Canada, where he was arrested and returned to Montana to stand trial. At his arrest, Valentine identified himself as Frank Dryman.

"I got out of the Navy in '49. I was just traveling around," says Dryman. "I was heading for Calgary. I'd been up there before. I had a girlfriend in Lethbridge, another one in Calgary."

"Pellett put his hand on my thigh," Dryman states. "I had a gun on me. I pulled it on him and shot him."

No one but Dryman and Pellett can say what took place in that car on the Hi-Line. There were no witnesses. In a way, it doesn't matter. Even if Pellett did attempt to molest the handsome hitchhiker, it's no cause to shoot a man down.

It was a sensational case, a heart-wrenching tragedy. Dryman was given the death sentence; death by hanging. He was sent to Deer Lodge and locked up in the old prison on Main Street. "Back then they had real cells," remembers Dryman. "Now we have a key to our own room. We have a Day Room, which I call the Daycare Room, to roam around in. Back then it was a by-God jail."

Dryman's case attracted national attention. His death sentence was challenged. He was granted a second trial, then a third, in 1955, with the venue moved to Hill County. At the eleventh hour, in February of 1955, Dryman's sentence was commuted to life and he was spared the noose.

Year after year, Dryman served his time. He stayed out of trouble, squandered his youth behind bars. His final two years in jail, he earned the status of trustee and was moved to a prison dormitory south of town, where the current Montana State Penitentiary stands. In January of 1969, eighteen years after the murder, Dryman was granted parole and allowed to move to California, where he lived under the custody of his brother, and under the conditions of parole.

Two years passed. Dryman met a woman with several children, married her. He checked in routinely with his parole officer. But things started to go south in his marriage. Dryman wanted out. He felt trapped.

In an impulsive move, desperate to escape his relationship, Dryman skipped town, violating his parole. With that move he became an "absconder," a wanted man. With that move, the wheels of fate started to grind forward with the inexorable weight of Greek tragedy.

"I just got on a plane and left," Dryman says.

He says it with the same straight-forward simplicity with which he explains shooting a man. Surely he could have figured out a way to get free of his

relationship without leaving town. Just as surely as he could have found a solution to whatever happened in Clarence Pellett's car in 1951 that didn't involve killing a man. If he had stayed put, made his parole meetings, he would still be free.

But that's not how it went down. Dryman traveled around aimlessly for a while. "I went to Florida. I went to a lot of places, but eventually I came to Arizona," he says.

"It's a great example of what we call 'criminal thinking,' " says Pam Bunke, Montana Administrator of Community Corrections. "It's the kind of pattern that gets people into trouble. Some people can't seem to change that behavior cycle."

Dryman showed up in Arizona City, Arizona. He went by a new name, Victor Houston. He settled. Slowly he created an identity that he occupied for the better part of forty years. He started a sign-painting business, a skill he'd gained while in prison. He became a notary. He made some friends. Later he opened a gaudy shrine, The Cactus Rose Wedding Chapel, where, as a licensed Deacon, he married people.

Over time Dryman, or Houston, amassed the necessities of his identity. He had the tattoos on his knuckles blurred into fuzzy blue blobs, unrecognizable as letters. He got a driver's license, a hunting permit,

owned a gun, all as Vic Houston. He even managed to work part-time for the census bureau. He joined the local sheriff's posse and volunteered on the search and rescue squad, befriended several area law enforcement officers.

He married again, to a woman almost thirty years his junior. In 1982, at the age of fifty, he fathered a child, a daughter. Cathy Houston is now twenty-nine and living in Portales, New Mexico. She remains Dryman's staunchest defender. All along, no one in Arizona City, including his family, knew a thing about his past.

Walter Dutton, a long-time acquaintance from Arizona City, remembers Houston as a town character. "Houston was known as Mr. Arizona City, Pink Panther, the Deacon, and Rattlesnake Vic," Dutton says. Dutton recounts Houston's community contributions as a member of the Kiwanis, the Pinal County Sheriff's Posse, the Moose Lodge and local Chamber of Commerce.

Years passed, then decades. The tension of living under a false identity faded away. Dryman truly became Victor Houston. He owned land and a trailer, attended school functions for his daughter, went on hunting trips, contributed in his way to the community. Houston stopped looking over his shoulder as life's inertia bore him along.

"For the last twenty years, I stopped thinking about it," Dryman says. He pauses. His gaze loses focus. "Would you believe," he comes back, "I just realized

this for the first time. I lived longer as Victor Houston than as either Frank Valentine or Frank Dryman!" He laughs at the strangeness of things, slaps his hand softly on the table. He is an old man with missing teeth, no vision, age spots on his face, his life largely spent, and yet, in these moments the handsome youth is visible underneath, the ladies' man, the town character.

But the wheels of fate kept lumbering after Victor Houston, catching up, taking turns no twists of fiction could match.

While Victor Houston lived his successful, albeit fabricated and fugitive, life in Arizona, one of Clarence Pellett's grandsons began rummaging around in some old news clippings in a box of his mother's belongings. Clem Pellett, a middle-aged oral surgeon outside of Seattle, was interested in pursuing his family history. It was mid-winter of 2009 when he stumbled on the news stories. He never knew his grandfather, or in fact, that Montana branch of his family. Nevertheless, when he read about his grandfather's murder, the overturned death sentence, and then realized that the murderer had been released and later absconded, his curiosity was thoroughly piqued.

"I figured he must be dead," Pellett says. So many years had passed. Even so, he was provoked. "I was trying to fill a hole in my family's memory. I was just out to do my own thing, to find out what happened."

Pellett did more than ponder the case. He hired a private detective to track Dryman, or the ghost of Dry-

man, down. And as it turned out, finding him wasn't all that hard. Within a year, private eye Patrick Cote followed leads to Glendale, Arizona, poked around until he heard about a guy with funny tattoos on his knuckles operating a wedding chapel, and showed up at Houston's door.

"He didn't fool me," Cote said, when he recalled finding Houston. "I was looking for those tattoos. I could see he had stars tattooed on his fingers to cover up the letters. I figured I had my guy."

Within days, police showed up to bring Houston in. Some of the arresting officers were Houston's friends. "They never even handcuffed me," Dryman says. "They just put me in the car and took me down to the station."

And so, at the age of seventy-nine, after living as a free man for four decades, Dryman was returned to Montana to face the parole board. He was charged with two violations of his parole—moving without permission and marrying without permission. In the big picture, it doesn't sound like much, but Dryman's case is unique, and sensational enough to attract attention, if for nothing other than Dryman's distinction as the longest escapee in state history.

On May 30, 2010, Dryman appeared before the Montana Parole Board. Clem Pellett, Penny Pellett, and several other descendants of Clarence Pellett showed up to testify at the hearing. They gave impassioned testimony about the legacy of the murder, the

burden that Clarence's death put on the family, and their wish for harsh punishment. Cathy Houston pleaded for leniency for her father. The board wasn't swayed. Teresa McCann O'Conner was the most vehement of the three-member board, saying that if it fell to her, she'd never let Dryman see the light of freedom again. The board gave Dryman a five-year sentence before he comes up for review again. By that time he'll be almost 85.

"They gave me life again," says Dryman. "Pellett says it's not about revenge," he continues. "but everything he said in his statement was about revenge."

As for Clem Pellet, he is at work with a ghostwriter on a book about his family story, highlighting the murder and subsequent history. "This has led to connecting with a family I never knew. It's been incredible," he says. "I hope some day Dryman will step up and talk to me."

Not likely, says Dryman. "What's he doing? Spending all that money to go after me. I'm just a blind old man trying to live his life. I'll say one thing, I will not help that man profit from me."

———

Past noon. Dryman shuffles back across the prison yard. It is a gritty winter day. Ravens croak in the distance. He mutters about missing chow, the little things that loom large when they are all you have to fixate on.

The Day Room at Unit D teems with prisoners. There are 161 men in that medium and minimum security unit at Deer Lodge. Some are handicapped. Several are in wheelchairs. Men mill around, or sit at tables with cups of coffee, play pool, talk quietly. It costs roughly $34,000 to keep a prisoner locked up every year. In Dryman's case, given his age and medical issues, it's probably more than that. A guard comes out of the office, watches Dryman make his way to his cell, a room like dozens of others that ring the central space. A bunk bed, two sets of shelves and drawers, two chairs—barely enough room for two men.

"Want to see my hate mail?" he shuffles through a small stack of papers and letters on a shelf, holds an envelope up close to his face. "This is the one."

An anonymous letter-writer vents at Dryman. "I hope you rot in that shitty cell… you dirt bag murderer… I'm glad to pay my taxes to keep you there."

He puts the envelope back. Next to it hangs a picture of him in prison garb, holding his four-year old granddaughter, Alicia.

"If I got out, I'd go live with my daughter in New Mexico," Dryman says. "That's what she wants, too." He touches the photo, reassuring himself, as if the image were Braille.

Given the disposition of the Parole Board, that future seems improbable. Craig Thomas, Executive Director of the Montana Board of Pardons and Parole, doesn't see much gray in Dryman's case.

"The conditions and requirements of parole are the backbone of our system," he says. "There are consequences when you break the rules. We take all the factors into consideration—the original crime, his prior performance in prison, the circumstances of his violations."

For Thomas, and the three-member board, the evidence of Dryman's rehabilitation doesn't overwhelm his infractions. "He falsified documents. He possessed a gun. He'd skipped parole and remarried. That's the bottom line, and it's not what I'd call being a model citizen."

"Look, I'm the Queen of Rehabilitation," says Pam Bunke. "But you have to follow the rules. The board was simply holding him accountable."

"I don't think this is a matter of rehabilitation, or of retribution," Bunke continues. "It's neither. It's just the law."

Bunke sighs. "There is no winner in this. There wasn't a win to be had. And it's very sad, because two people basically lost their lives."

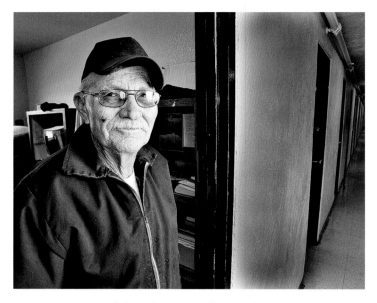

Dryman poses outside his cell. It's a small room about the length and width of a bunk bed, and he shares it with another man in the low security section.

Opposite: Dryman recalls how he was returned to prison after forty years as a free man.

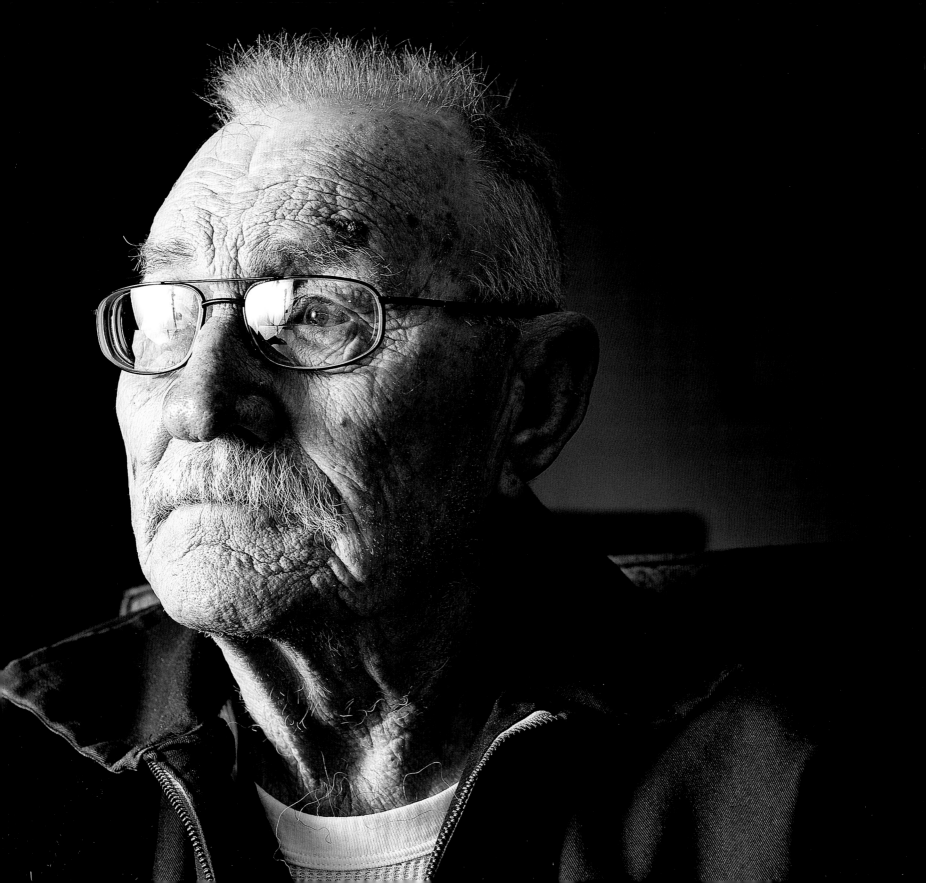

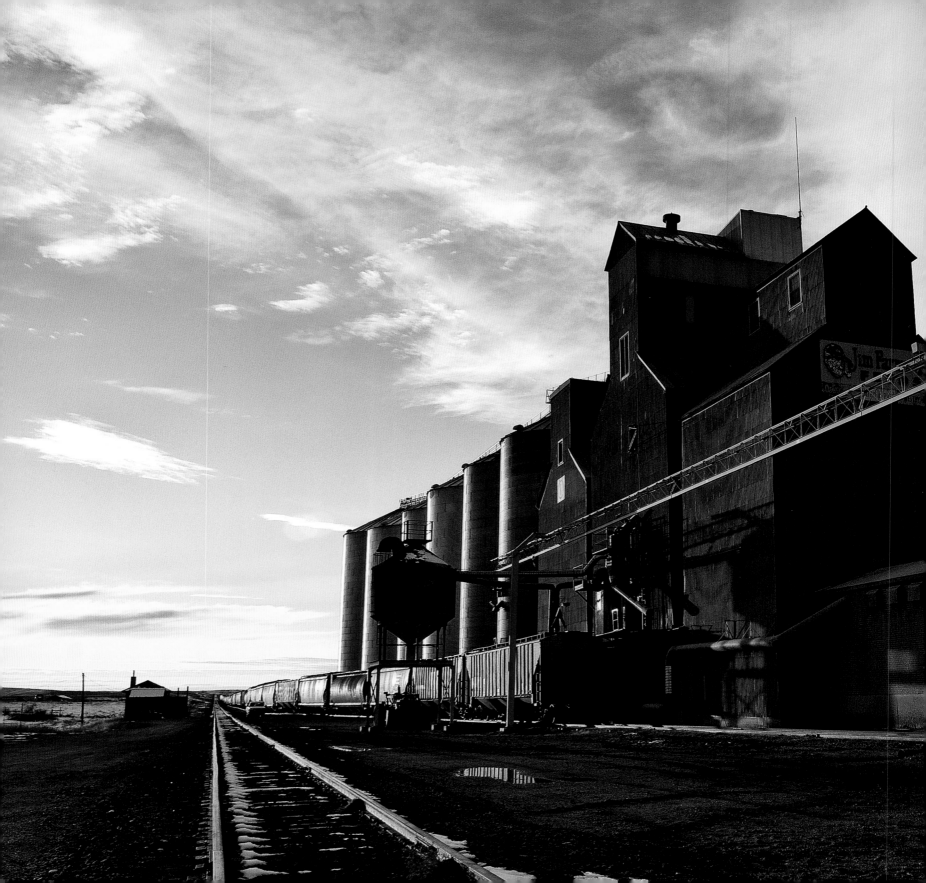

Genuine

PHOTOGRAPHS

Like many rural Montana towns, Westby's history and economy are tied to its grain elevator and the railroad. Westby was originally founded on the western border of North Dakota (hence the name), then moved three miles northwest, crossing the state line into northeastern Montana when the railroad came through in the early 1900s.

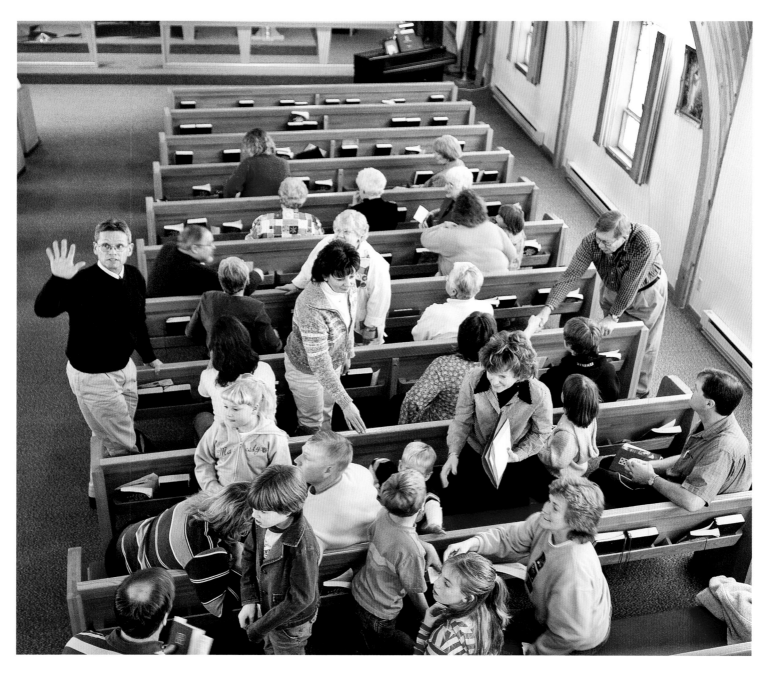

Parishoners at Immanuel Lutheran, the biggest of Westby's two churches, greet each other before the service. Church and family are paramount in Westby, making it a good place to raise a family. "You've got forty grandmothers to watch your children here," one church member said.

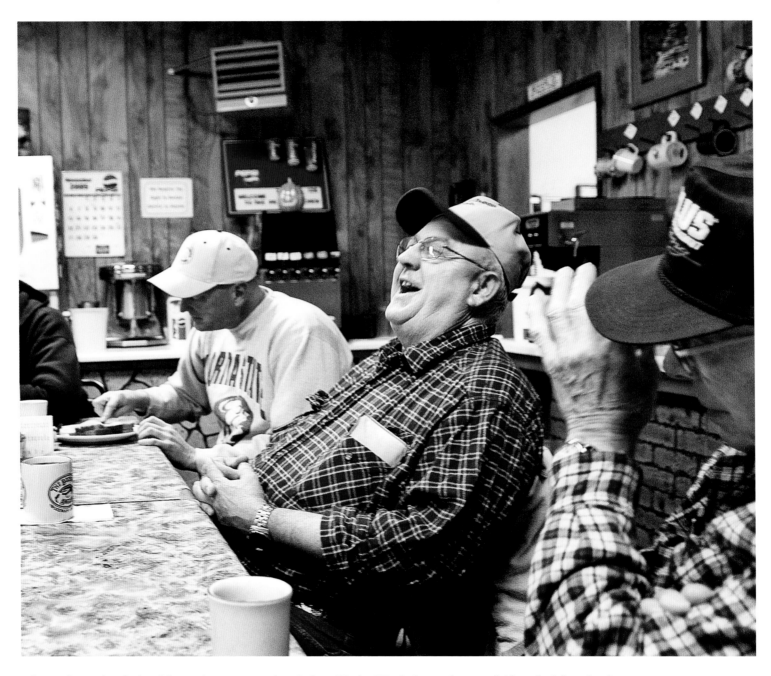

The regulars gather for breakfast at the Prairie Kitchen Cafe in Westby. Westby lies in the grain fields and oil derricks of extreme northeastern Montana, two blocks west of North Dakota and eight miles south of Canada.

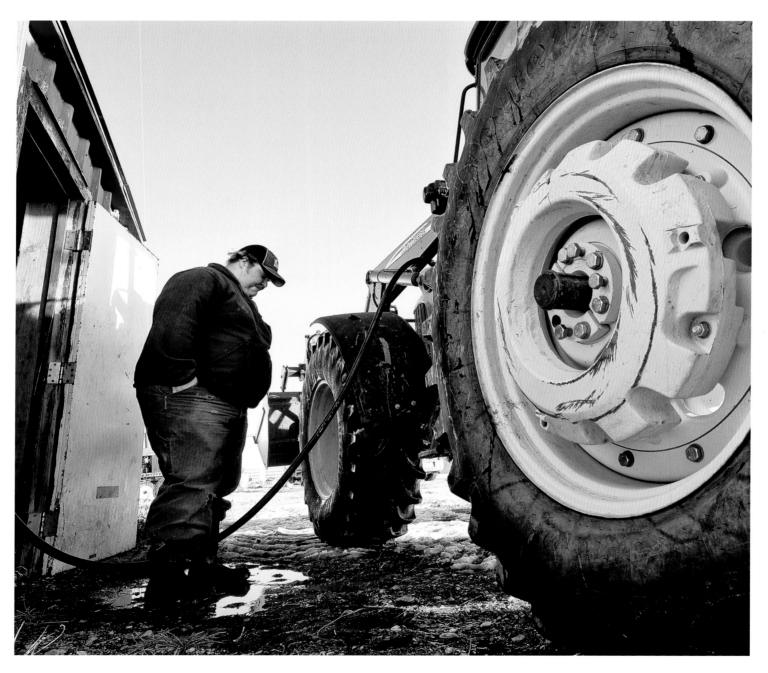

Jeff VandenBos works construction when he's not on the family ranch outside of Valier. Young adults like Jeff are perhaps rural Montana's most valuable assets, but Jeff and his brother Jere and sister Gina have no plans to leave. "We all have different jobs to make it by," says Jere. "I like it around here," Jeff adds. "I need the construction job to get money so I can buy land if it ever comes available."

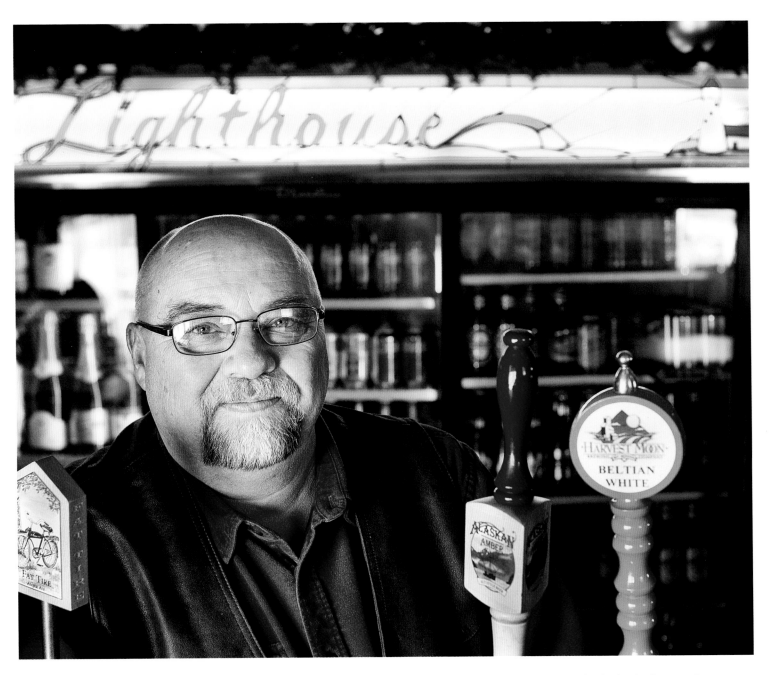

Many of those living in small Montana towns are like Bob Kovatch, who was born and raised in Valier, then left after high school. He and his family moved back years later, bought an abandoned property, fixed it up and opened the Lighthouse Restaurant. "We had no money," Kovatch says. "We just had an idea."

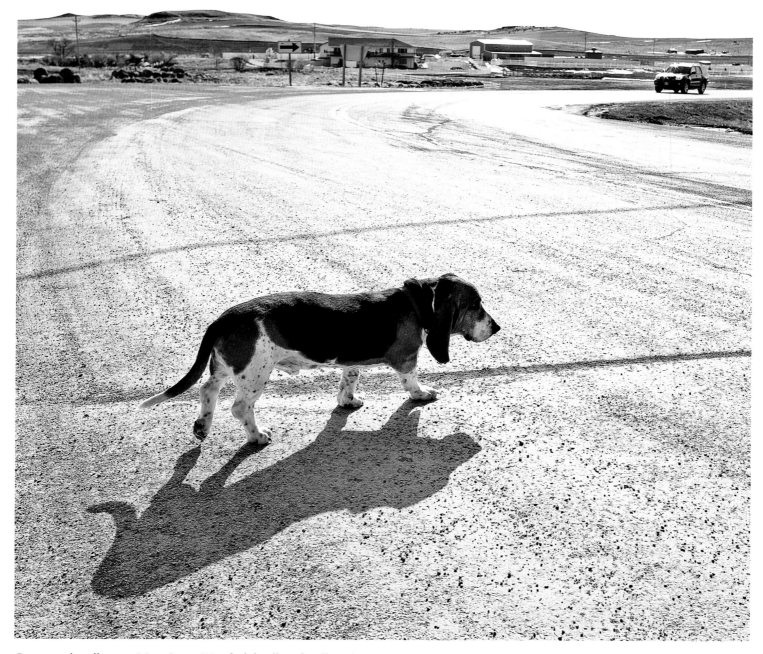

Beauregard strolls across Main Street, Winifred, heedless of traffic. "They just started calling him The Mayor," says Ed Heggem of his basset hound. "I guess because he was always around. He'll come to about anything. Food especially."

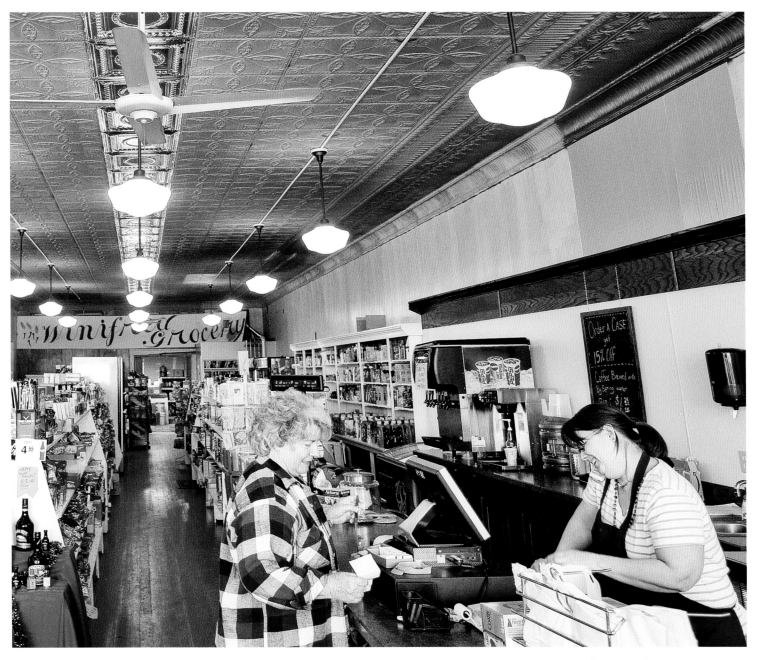

Eileen Stulc, right, manages the Winifred Grocery which includes a deli, bakery, coffee shop, Wi-Fi station, cell phone booster, public computer, dvd rentals, and liquor store. Stulc says she lives nearby in the house she grew up in. "I just have always liked it here," she says.

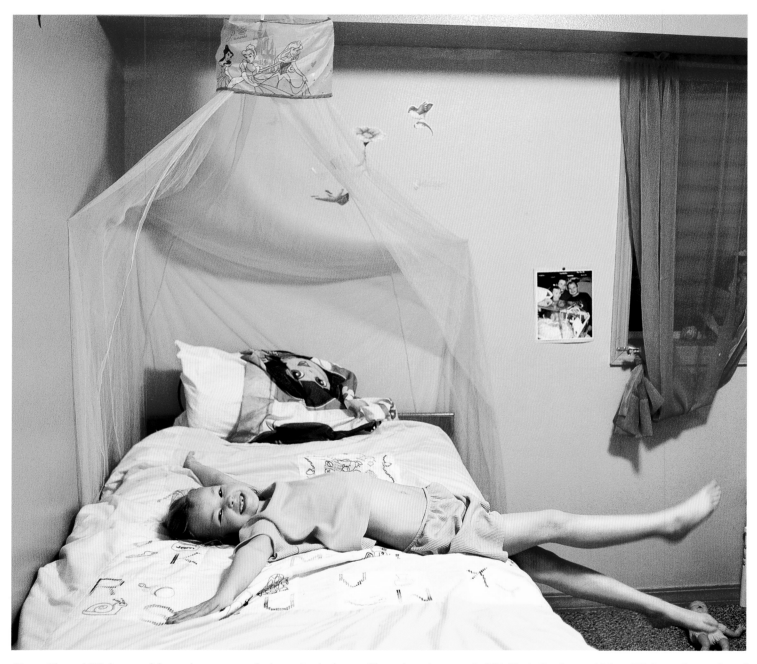

Young Shantyl Wichman celebrates her very own bedroom in the home of her adopted parents in Winifred. Gordon and Mary Wichman have adopted or have been foster parents to more than sixty children. Gordon says he and Mary grew up in Winifred, left for teaching jobs, then accepted Norm Asbjornson's offer to return. Asbjornson built them a twelve-bedroom, 6,000-square-foot house and ultimately hired Gordon to run his new sign shop.

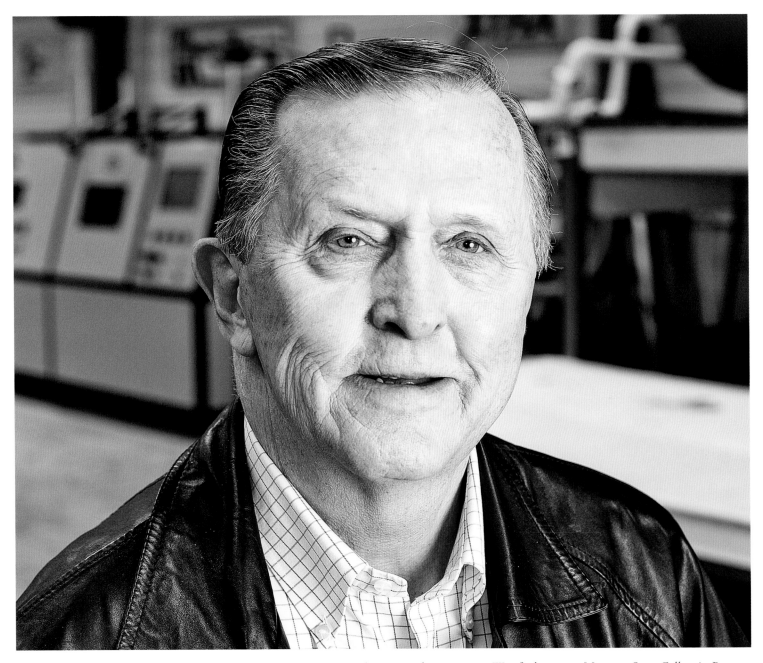

"I have a lot of love for the town and the people in it," says Norman Asbjornson, who grew up in Winifred, went to Montana State College in Bozeman and became very successful. Asbjornson has built houses to bring in school teachers, donated money for curbs and sidewalks, and planted hundreds of trees. He started a sign company in Winifred that competes nationally. "What [Asbjornson] wants to do is invest in the future of Winifred," says Winifred Cafe owner Frank Carr. "A lot of other small towns are going backwards. We're going forward."

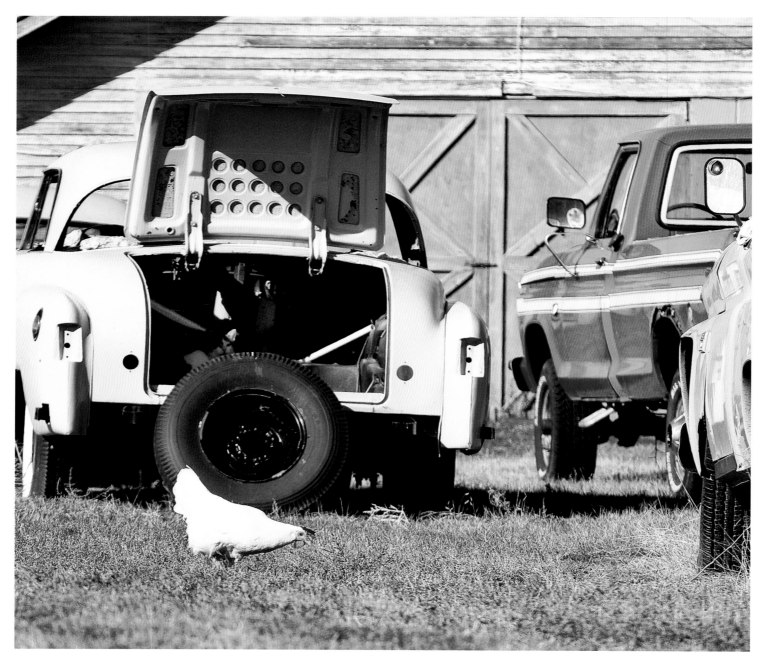

Chickens range free among vehicles in various stages of restoration at a home in Rapelje.

The road out of Broadus heads through fog and hoarfrost on a spring morning along the Little Powder River.

Bittersweet Prairie

HEARTACHE FOR PLACE

The only thing Tana Kappel wants from the family homeplace up on Stinky Creek, north of Saco, is the old cast-iron cookstove.

"It must weigh seven hundred pounds," she says. "I don't know how I'll get it from the basement." The ranch she was born on, in the northern half of Phillips County, just below the Canadian border, is being sold. Neither of her brothers is interested in it, and Tana's mother, Edith, has lived in Billings for decades, managing from afar.

"It's time," says Edith, when we meet her for lunch on the west side of Malta, the largest town in Phillips County. "But it's bittersweet. We had good years there."

Bittersweet. It's the taste of this part of Montana. The land aches with lingering drought, the population base is hemorrhaging young people, economic desperation is scratch-the-surface deep. Phillips County is a microcosm of the plight of the Great Plains West, a place on the cusp of wrenching transition, where little is certain and the stakes are great.

At the same time it is a county that sweeps to the long horizon, more than three million acres of short-grass prairie, sage flats, rounded hills dotted with glacial boulders, ponds brimming with waterfowl. If space were wealth, Phillips County is rolling in it. A county half again the size of Yellowstone National Park where it isn't a leap at all to imagine milling herds of bison, Assiniboine tepees in a valley and the howl of prairie wolf.

Space, and the customs it engenders. Here drivers still wave to each other on the highway.

Precisely because they have been unappreciated and ignored, places like Phillips County hold a great, hidden promise. The Great Plains as a whole has been losing native prairie to cultivation in whopping gulps. Between 1950 and 1990 grassland habitat was lost at the rate of nearly seven hundred thousand acres every year. Native shortgrass prairie, like that in Montana, is down to twenty percent of its pre-settlement extent.

Populations of upland birds like

Opposite: Prairie storm, north of Great Falls.
Right: Sierra Schneider, from the flatlands of eastern Montana in Wibaux.

the mountain plover, long-billed curlew, lark bunting and a score of other species, are under severe duress, as is the prairie dog, whose range has shrunk from historic levels of twenty percent of the Great Plains to barely one percent. Black-footed ferrets get all the press, but if prairie dogs go, they take out a whole pyramid of ecological structure. To these species, islands of intact habitat are precious and rare havens.

By virtue of its glacial soil, Phillips County lends itself more readily to grazing than to crops, and more than eighty percent of it remains uncultivated. In many ways, the land is more pristine now than it was two generations ago, when it suffered from the aftermath of the homestead rush.

At the heart of the county, lapping up against the Little Rocky Mountains, the Nature Conservancy's Matador Ranch stands as a testimony to that landscape potential. It is sixty thousand acres of rolling prairie grassland, ridges dotted with pronghorn, subtle streambeds worked by beaver, isolated trees where great horned owls and rough-legged hawks hunch in predatory vigil. Like the majority of the county, most of the Matador's acreage remains unbroken sod, open range, sparsely punctuated with livestock.

As Randy Matchett, the wildlife biologist in charge of prairie dog and ferret recovery for the U.S. Fish & Wildlife Service put it, "Phillips County is one of those rare places left with enough intact landscape to actually do landscape ecology!"

After lunch, while we drive east to Saco, Edith fills in her family history. Her parents migrated from Minnesota during the first decades of the 1900s, and homesteaded near Brockton, south of the Missouri River. Edith boarded in town on the Fort Peck Reservation during high school. Later she earned her teaching certificate and taught in tiny communities like Poplar and Loring.

"One year I had only a single student," she remembers. Her husband, Harold Kappel, courted her while she taught near the Canadian border. They married and built the place on Stinky Creek in the 1950s. Harold Kappel was a bona fide cowboy; long on personality, prone to drink and victim of horrendous accidents. He died of lung cancer at fifty-nine.

Theirs is the sort of family history common to eastern Montana. A couple of generations deep, rooted in homestead fever, tempered by killing winters and drought and superhuman effort and barely enough good years to keep from selling out.

———

A day earlier I had shared lunch, the meal ranch families call dinner, with Dale and Janet Veseth. They live along Dry Fork Road, south of Malta, in quiet country full of sky. Their house is nestled next to a cottonwood grove in a shallow valley that, this summer of 2002, is dry.

"We really apologize for the way the land looks," Dale said when we shook hands. "This is the worst I've ever seen it." Apologizing for a landscape. It made the word "steward" flash in my head.

Dale pointed at the shallow creek bottom where he said red-tailed hawks perched. "It hasn't had water since 1996. We haven't had an inch of rain from a storm since August of '99." Inside the Veseth's door a hand-lettered sign reads, "We ain't always ready for company, but we's glad you came." The house is cluttered with buffalo skulls, fossils, books.

Dale's roots go back to the 1880s, when the Veseth brothers came from Norway and kept moving west, eventually working their way north from Judith Crossing on the Missouri with a herd of sheep. One Veseth sold out in 1903, another froze out during the killing winter of 1906, but the third one stuck, and the family has evolved into one of the notable ranching names in the county.

"Back in the homestead years," said Dale, "people could see dozens of tarpaper shacks from their doorways. Then the Dust Bowl and Depression came along and you could buy all the land you wanted for a dollar an acre." During boom times Phillips County's population has been as high as twenty thousand, but it has been on a long, steady, downward slide. In the last census it shriveled to an anemic forty-five hundred, down another ten percent from the previous decade. One person for every 670 acres.

While we ate hamburgers provided by Veseth cattle, Dale summarized the family business history. "We ran sheep till '43, then cows until 1980, when we put five thousand acres into cropland just in time for the education of the '80s," he grimaced at the memory.

That hard-knock decade combined a series of dry years with "the problematic proposition of making farmers out of old cowboys. After that we resorted back to cattle." That decision, made by many families in Phillips County, might just be the saving grace for this prairie.

Most of the lunch conversation worried at the edges of what seems to underlie all the rest out here, the equation for survival. It is a formula endlessly concocted out of the vast land base, resilient people who don't want to leave, government lands and support programs, and a ranching economy which is, right now, a pretty sketchy bet.

Always, the palpable whiff of economic strain, implied in the reference to selling cattle off early or sharing a hired man with the neighbors. The Veseths host hunting groups from time to time, and talked about developing guided bird-watching trips and other eco-tourism packages. There has even been rumor of negotiating arrangements with the U.S. Fish and Wildlife Service to raise black-footed ferrets for cash.

"I live here because I like it," Dale concluded. "But something has to change. Folks out here are really scared. It's been a twenty-year drought to start with.

Most ranchers depend on federal land for grazing, and that's getting tighter all the time. People are afraid of prairie dogs and the Endangered Species Act."

I thought of Linda Poole, the Matador Ranch manager, who expressed hope for some workable solution in this part of Montana. "I've never met more educated, committed, genuine people," she told me. "They are truly open to possibilities and discussion. If there's a place where some new and sustainable agricultural scheme might work, it is right here."

I am still thinking about the Veseth place, and Dale's apology for the land, when we arrive in Saco. Edith remembers nightclubs and hotels and hardware stores, but much of Main Street Saco is now boarded up, coated with dust, or for sale. In less than two minutes we finish the town tour and head north.

Nothing is close in Phillips County. Plenty of time to think as we rumble down the dirt road toward the Kappel place, across the Milk River, a turbid, sluggish flow bordered by cottonwood trees and a valley-wide strip of cropland.

I mull over the meeting I had earlier in the day with Mark Manoukian, the County Extension Agent in Malta. Manoukian is a soft-spoken man who slides easily towards humor.

"I handle everything from youth development to what emus eat," he told me.

He identified the loss of young people as the most pressing problem for the region. "We'd take all the youth-at-risk we could get right now, just to have some youth." I asked him about the plight of agriculture. "Ranchers have to shoot at a moving target with every decision," he said. When to ship cattle, whether to plant crops, when to buy feed, how long to wait on prices, which kid inherits the place. Every step is an abyss of uncertainty.

"Everyone's looking at economic schemes for survival—value-added agricultural products, tourism, industry—but nobody has real answers. We need some local solutions, not just government ones. Politics are too fickle and inconsistent." Once more, that elusive, tantalizing hunt for direction that every conversation hovers over.

Around a corner, Tana Kappel points up into the rumpled hills. "This is where we'd herd cattle on horseback every year." I hear the kid on a horse in her voice.

Just before a small bridge we turn in the drive. Stinky Creek, which got its name from a time when a bunch of dead sheep lay in there after a bad winter, actually has more water than you'd expect. A great blue heron flaps up from a bend. Vegetation crowds the banks.

The realtor is waiting for us in front of the house. "Everyone knows a neighbor who's selling out," he tells me.

Tana and Edith stand in the driveway. The front window has been broken. The rail fence is half torn down. The siding looks parched and cracked. "Excuse me if I sigh a lot," Tana says, slinging a camera over her shoulder.

Inside, abandonment is pungent as mildew in the stale air. The house is a husk of a building. There are dead flies littering the counters. The corpse of a mouse lies beneath the washing machine hookup.

Tana and Edith walk from room to room, not speaking, not touching anything. Their faces work with memories. Years there, young years, hopeful seasons, the sounds of livestock outside, smells from the kitchen on a bitter winter afternoon, shouts of children playing along the creek—all there on their faces in the dust-struck stillness.

In the basement, tucked away in a closet, three old saddles hang from a rafter. "Here's the little one," Tana exclaims, "the one I used to ride Missy—my old horse, Miss Montana."

The cookstove squats in another cobwebbed corner. I take hold of it and heave up. The beast barely shifts.

"It's in good shape," Tana says. "Guess I'll have to rent a trailer, hire some local kids."

There is more. Outbuildings, the corral and loading chute, a big metal shed creaking in the wind. A pair of old hockey skates we pull down from a rafter. A vintage John Deere tractor, model V, with flat tires.

The "buffalo jump" that no one is actually sure was ever a buffalo jump.

Tana and Edith argue briefly over whether the school bus came to the house or the kids had to walk down to the main road. I leave them and stroll toward the creek.

It comes to me there that the thing that unites everyone I've talked to is a stubborn passion for this arid, windswept, mile-eating land, and the determination to find a way to stick. No matter the job or family history or political persuasion, land is the thread that binds.

———

Katy Matovich teaches in a one-room school in the boom-and-bust town of Zortman, tucked up against the Little Rocky Mountains under the hulking shadow of an abandoned gold mine. "I came from Oklahoma City," she said, "a single mom with two girls, and got a job in Sun Prairie, population zero, forty miles out a dirt road. I found my husband there," she laughed. "He was the fiddle player over at a community dance in First Creek Hall."

"America needs to see this!" she added, earnestly. "People need to see that there are still places like this." Whatever resilience and stamina and optimism exists here, I think, rests on that kind of allegiance to place and that loyalty to a way of life.

Francis Jacobs drove in from twenty-two miles out Dry Fork Road to meet me at Kalamity Kafe in Zortman. He's ranched the same ground since 1958.

"It'll rain," he said, with a rueful smile. "We just have to keep pushing ahead. There have always been unknowns. We've lived through drought before.

"Education is the key right now," he went on. "This country has been good to us. We just can't ask it to do more than it can."

I rejoin Tana and Edith by the car, but nobody gets in to leave. The realtor shakes hands and drives away. The wind claps a piece of tin in the corral.

"Maybe we should drink a beer and toast the old place," suggests Tana. She pulls cold, long-necked bottles out of a cooler. We clink them together and drown the dust in our throats, cut the mist of memories. There is nothing left to talk about, so we just look at the house under the dome of sky.

I offer to take a picture of them in the yard. They hand me their cameras and move toward the house to stand together. A magpie flaps across the drive. I frame them there, with the weathered, empty place, and behind that, the fuzzy, sage-dotted distance; an expanse equal parts heartache and promise. The two of them lean against each other, holding their beers up into the hum of space.

A dirt road empties into the town of Rapelje.

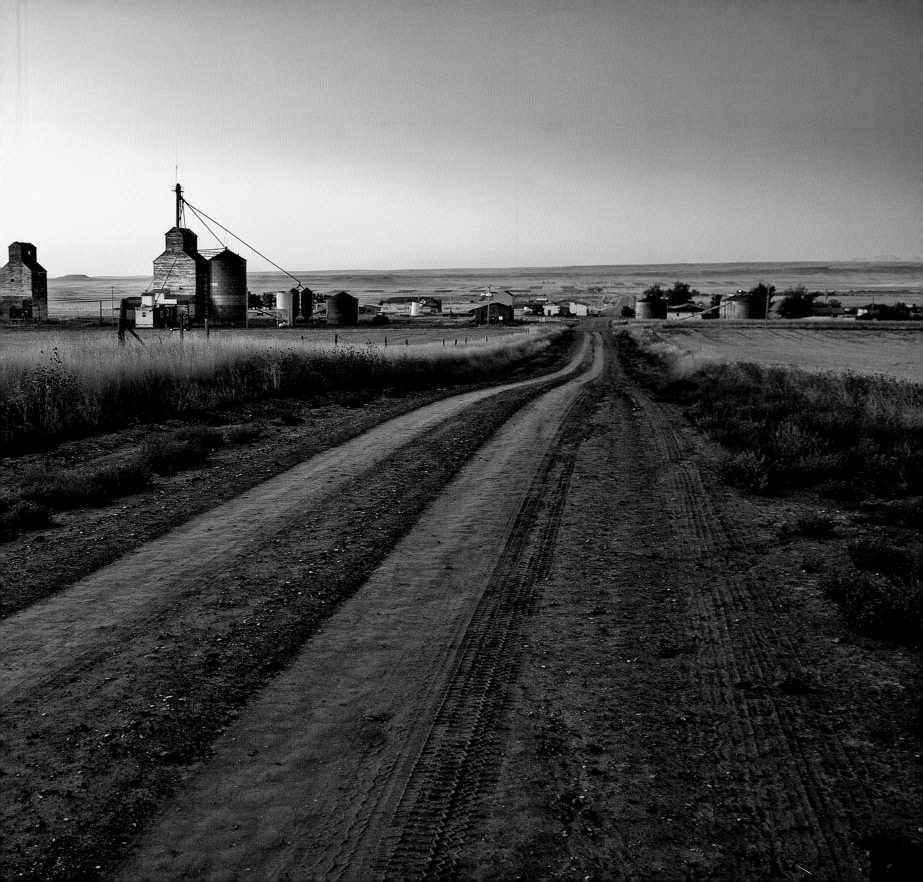

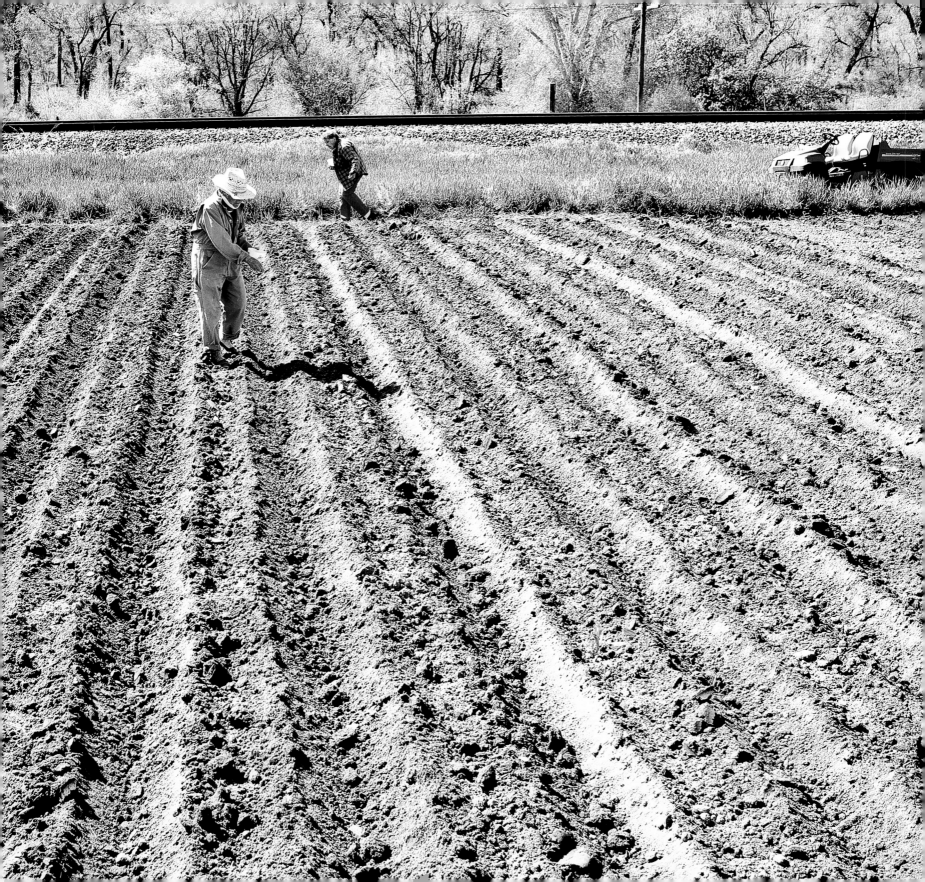

The Cake Ladies

HOLDING HISTORY ALONG THE YELLOWSTONE

Barely light, just after five, and Fritzi Idleman has been up for an hour already. She wears coveralls, yellow rubber boots. Her neck is in a soft brace, a recent health nag from a car accident thirty years before. She carries a bucket of compost scraps and a pail of chicken feed toward the hen house. It is her eighty-first year, but she moves with purpose and speed. Cats scatter around the yard, some with missing legs.

"We're a cat orphanage," she says. "I think there are thirty-eight of them right now. People think kittens are cute, but when they grow up and aren't so cute anymore, they just drop them off on the side of the road. They seem to collect here."

She points out the remains of the original rock barn, a building more than 100 years old that finally succumbed in the 1997 flood. She pauses in the doorway of the hen house. A rooster crows, shattering the silence. She points west into the shadowed, misty grove of cottonwood trees where old wagons and rusted farm machinery hunker in the tall grass.

"Right there is where Captain Clark stopped on his way back from the Pacific in 1806. He spent a couple of days here, carving canoes out of cottonwoods and then he floated on down to the Missouri," Fritzi says.

"People told us that when we were growing up, and historians have confirmed it."

Fritzi is in constant motion, flinging feed, pouring water into bowls, scattering chickens, pointing to things, talking non-stop. "I talk people's legs off," she says, not as an excuse, but as fact.

She walks back toward the house, where her sister Tia works in the kitchen. The day rises up warm and gentle.

Inside, light pours through the large, rectangular kitchen window, filling the room. Tia Kober pauses in front of the view, resting her hands on the edge of the sink. She gazes out, as she has countless times over her seventy-nine years.

The window frames the spring green pasture below the farmhouse, where a handful of cows laze through the warming morning. Yellow cliffs loft above the valley across the way, a rugged scarp of sandstone where, not that long ago, if your point of view is elastic enough to span a few generations, Indians rode horses and fought battles. Running through the center of the

Fritzi Idleman and her sister Tia Kober plant squash near the spot William Clark and his men carved canoes to float down the Yellowstone River on their way back from the Pacific in 1806.

window frame, dominating the scene, flows the Yellowstone River.

"That awful, beautiful river," Fritzi says.

It is brown with silt, flooding over the midstream island, pouring around the corner where the irrigation company diverted the channel to bring more water into the downstream ditch, and by doing so, slammed the current into a corner of the front pasture. Tia notices the riverside fence, the third one her brother has put in, being eroded by the bank-chewing flow. In her lifetime the river has swallowed several acres of their precious pasture. The Yellowstone is the means to the farm's survival, and it can also be, at times like this, the greatest threat they face.

Embedded in this frame of country, in the burgeoning flow muscling past, is the collage of her family life, and the stories that stick in the currents of time. Her eyes soften. The fabric of time has become as sheer as silk. She slips through the years, tearing through decades, images as fluid as the river rippling by. The view recedes, becomes the palette for the jumble of memories that crowd forward. Her own memories, and also the stories told down the tunnel of years, all of them hung up here at this bend of river beneath the blue sky and loom of cliff.

That story runs back to another river, the Volga, in the time of the Bolsheviks. Tia and Fritzi's ancestors were German Russians, coaxed by Catherine the Great to farm the fertile Volga valley. Under Catherine's rule, they were allowed to hold on to their language and culture, to honor their heritage. But later, when the Bolsheviks gained influence, the Germans in the region were oppressed and mistreated. Life became unbearable enough that many people left everything and headed west.

"We are so lucky," Fritzi says. "Our parents' families traveled all the way across Europe. They came across the ocean. Then they came most of the way across this country to settle here, in this spot. What a place they landed in!" She gestures toward the river, toward the Beartooths, pillowed in snow, toward the arc of sky with herons and geese flying through it. "I think about that every day."

In the early decades of the 1900s a number of German immigrants came to rest in the vicinity of Park City, along the Yellowstone. They worked as laborers, as little more than indentured servants. Most were uneducated. Few had money. The West was still largely a frontier, brutal and beautiful, raw and grudging.

Their father had a seventh-grade education. Their mother stopped in the third grade. Their families worked in fields, raised horses for the cavalry, planted sugar beets, slowly earned a reputation and established their niche. Their parents fell in love and married. Little by little they found community, and in 1925 they

moved into the house with the view. Eventually they came to own the home, along with roughly eighty acres of irrigated bottomland. There they raised five children. And they bequeathed them the legacy of place.

The house, now, is part home, part museum. The walls are crammed with photos—family portraits, river scenes, train derailments, blizzards, harvests, men with mustaches and heavy, formal coats, children clambering on wagons, contemporary reunions. Everything reminds the sisters of another story, another picture. They keep unearthing photo albums, bringing forth yellowed news clippings, trying to remember names of former neighbors, teachers, friends.

Tia is the quiet one, but the one who remembers the details. Her laugh is a surprise, an infectious one. Fritzi talks through anything, insistent as wind, full of gumption.

"Anyway…" she says, and gallops off on another tale about the country school they attended or the stooped labor of harvesting sugar beets or the train derailment or the hobos during the Depression who came through by the dozens, who sometimes slept in the barn, and who relished the slices of homemade bread with butter slathered on that her mother handed out.

"In the tough years when we didn't have much food," Fritzi remembers, "Mom would say, 'there's always bread and butter!' "

Like most of the brothers and sisters, Tia and Fritzi went into education. Fritzi taught in Belgrade, in Bill-ings, and in Rosebud. Her husband drove Greyhound buses. Tia taught in Savage, and then spent most of her career in Whitehall, where Tia Kober Elementary School is named after her. She brings out a twenty-foot-long scroll with the names of all her students inscribed on it.

"The sad thing is that I've seen seventy-five of those kids go to the grave," she says. "Car wrecks, suicide, cancer."

After Fritzi's husband died, and Tia retired, the two sisters made the obvious move. They came home. For more than twenty years now they have lived in the family house, gotten up at four, done chores, continued their involvement with the local community, collected stray cats, kept the stories alive.

And they have baked cakes. Angel food cakes especially, but all manner of cakes. Hundreds and hundreds of cakes. So many cakes over so many years, commemorating so many occasions, that they have become known as the Cake Ladies, with a metal sign in the driveway to prove it.

"We figured we made more than four hundred last year alone," says Fritzi. "Each angel food cake takes a dozen of our eggs!"

Another photo album comes out. Cakes on every page. Cakes in the shape of a Greyhound bus, a

Montana driver's license, a tennis shoe, Big Bird. Cakes to commemorate birthdays, union hall parties, graduations, babies, cancer recovery.

"I even made the cake for my own surprise birthday party when I turned eighty!" exclaims Fritzi. "They concocted some crazy story to get me to bake a cake, and darned if it wasn't for me."

"We might be rich if we'd sold all those cakes over the years!" says Tia.

———

It would be easy to relegate this backwater slice of life to a bit of quaint and anachronistic folklore, a throwback. Fritzi and Tia don't have cell phones, don't use a computer, wouldn't know a text message from a telegram. The thrust of culture has rocketed on past them into a world based on material acquisition, technological gadgetry, and social and geographic mobility; but it has done so at the expense of fractured extended families, communities that lack roots, and a truncated sense of history. For many of us, history only extends back as far as we can remember.

Tia Kober and Fritzi Idleman are steeped in their history, surrounded by their family, and reminded in every view, every event, and every bit of topography of the place that has woven the fabric of their lives. Their lack of modern sophistication is supplanted by that wisdom. By the force of their existence, they reassert that legacy every day. More important, they provide an example of another way to live, one that might well inform the rest of us.

Around mid-morning it is time to plant their two-acre garden. Their brother Al, who lives on the other side of the interstate and handles the heavier farm work, has signed on to help.

Before that, Tia slowly backs the car out of the garage and takes a drive around the property. It doesn't take long. There are only eighty acres, and thirty of those were lost to the highway when it blasted through the middle of the family property in the early 1970s.

"They gave us six hundred dollars an acre for irrigated land," says Al, a bitterness in his voice that persists forty years later. "Imagine the value of those thirty acres over all those years." What they have instead is the constant roar of traffic and a farm ripped in half.

"They should have built the highway up on the bluffs," Tia gestures to the high, arid bench to the north. "Then they could have saved all this bottomland. That highway covers the country we used to crawl around, blocking sugar beets, when we were kids."

They point out the site of the old country school they all attended, the dilapidated slaughterhouse, the home that had to be moved to make way for the highway, the old blacksmith shop, root cellars, the siding where the train stopped to load sugar beets.

"Every eighty acres had another family on it," Al remembers. "Some of those families had thirteen kids.

Every fall we had sugar beet vacation—two weeks off school to work in the fields at harvest time."

"This is the old Yellowstone Trail," Tia says. The car bumps along a dirt track next to the brimming irrigation ditch. "It ran from South Dakota to Yellowstone National Park." The trail gets rough and Tia carefully backs the car in a three-point turn at the edge of a tilled field.

At the garden plot Al fires up the small tractor between the highway and the railroad track, starts plowing the shallow furrows. Plastic irrigation pipe rests along one edge of the field. Fritzi and Tia have already planted another garden closer to the house. That one is full of cabbages, tomatoes, cucumbers, peppers, strawberries, carrots. This larger section is dedicated to squash and melons, pumpkins and an exotic gray squash descended from seeds brought over from Russia by their parents' families. Squash that came half way around the world and has lasted three generations, still going strong.

"That squash travels all over the place from here," says Fritzi. "It goes with relatives and friends to North Dakota, down to Denver, out to Seattle."

"Plant every fourth row," Al admonishes. "I'll be back to cover the seeds."

Fritzi and Tia count the rows carefully, shove a stake at the end of each planted furrow. They walk down the soft dirt, dropping seeds out of small plastic buckets. Three rows of melons, two of pumpkins,

two of gray squash… They wear sun hats. They walk carefully along, stooped with age, but full of purpose. It is warm. A soft breeze wafts out of the east, stirring the new cottonwood leaves. The lilacs are blooming, fragrant as perfume. Finches and warblers call from the underbrush.

"We share food," says Tia. "That's what you do."

"People just stop by and pick pumpkins and squash," adds Fritzi. "We could never eat all the food we grow. We're still getting onions and potatoes and carrots from last year out of the root cellar."

———

Later, back at the house, Tia and Fritzi conjure a spaghetti dinner and garden salad out of nowhere. They have already put in a nine-hour day. Al comes over with another brother who is visiting. Fritzi's daughter and son-in-law drive up. There is a prayer, plenty of good-natured ribbing, bowls of food passed up and down the table, more photo albums pulled out, details disputed. And there is the inevitable angel food cake with raspberry sauce for dessert. Serving cake by the porch window, musing about the prospects for an afternoon nap, Fritzi suddenly points outside to a rose bush.

"That bush is a hundred years old," she says. "I've known that rose all my life."

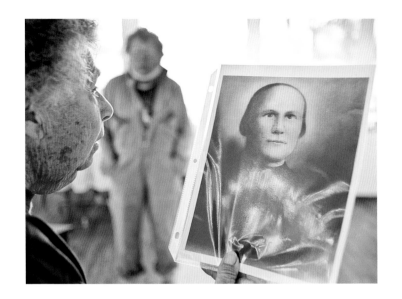

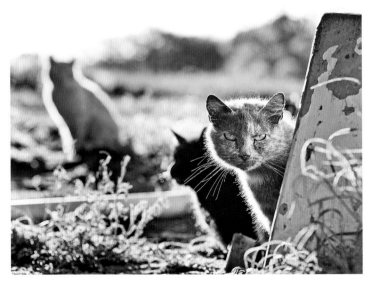

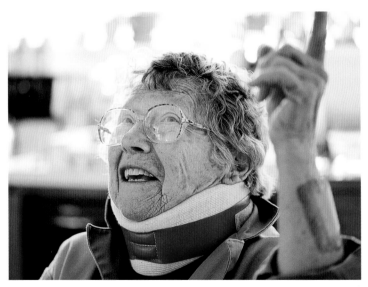

Opposite: Tia Kober brings the newspaper into the house. Tia and Fritzi wake every morning at four, feed the chickens and cats at five-thirty, call their sister Rosemary in Lovell, Wyoming, at six, then read the paper at six-thirty so they can give it to their brother Al, who lives nearby, at seven-thirty. Clockwise from lower left: There are about thirty cats on the property, the sisters say. "We're not crazy about that many cats," Fritzi says. "We're an orphanage!" The sisters have a trove of historic family photos to show, including this picture of Great Grandpa Runk, who lived all his life in Russia. Tia sets the porch up for a family gathering. "I talk people's legs off," says Fritzi.

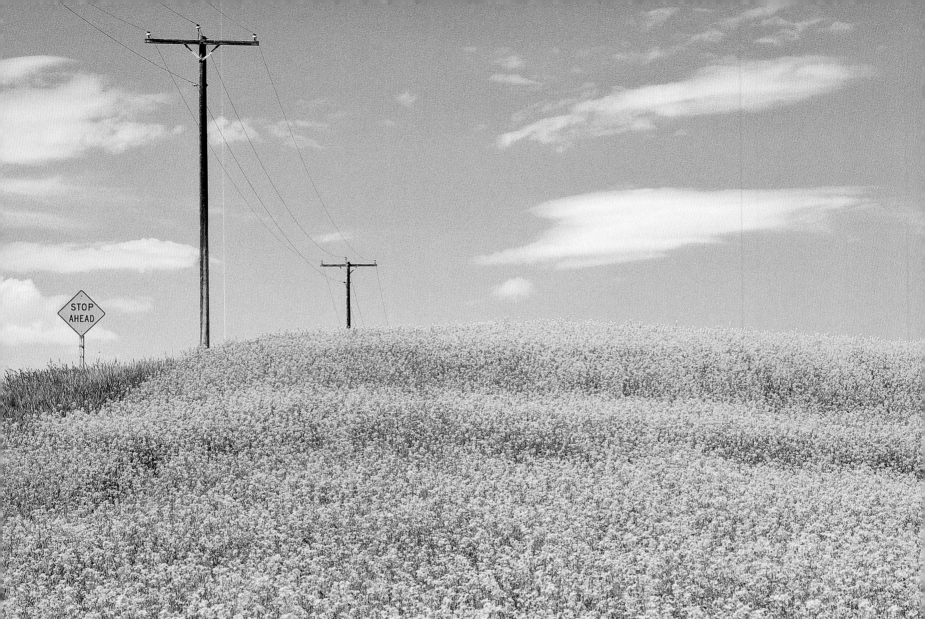

From Dirt to Fuel Tank

KEEPING ECONOMY CLOSE TO HOME

When I meet Brett Earl at the Earl Fisher Biofuels plant on the outskirts of Chester, he is wearing a white lab coat and Harry Potter-style safety glasses. He looks more mad scientist than fourth-generation farmer. When I shake his hand, I notice a gleam of excitement in the eye of a guy who has had a few Eureka! moments lately. While he still farms the family place south of Chester, near the Marias River, Earl's professional training is in chemical engineering, a background he is putting to daily use in his current project.

His business partner, Logan Fisher, also farms land that has been in his family for four generations, seventeen miles outside of Chester. He and Earl came together over a problem that has frustrated area farmers since buffalo roamed the prairie.

"I remember my grandfather complaining about transportation costs and all that money leaving town," remembers Earl. "Then I heard my father say the same thing. He figured that every third crop of wheat he grew went to pay Burlington Northern."

"When we found ourselves echoing those same tired lines over coffee," Fisher adds, "we started wondering if there was something we could do about it."

With Wall Street yo-yoing and fuel prices spiking, transportation costs and sustainable local economies are issues that have been getting everyone's attention. Many of us are scrambling for ways to soften financial blows and craft equations for economic survival. In the rural West, places like Chester, where the economic crisis has been building longer and hitting harder, folks are a little farther along on the learning curve. Back in 2005, Earl and Fisher decided it was time to stop bitching over coffee and start taking action.

Their strategy? Go green. Go local.

They did some research. Earl cooked up a batch of chemistry experiments. Once they firmed up an idea they had enough confidence in to make a leap of faith, they wrote a business plan. Combining their own resources, a loan through the Montana Department of Agriculture's "Growth Through Agriculture" program, and community development money, they cobbled together start-up capital. They bought a dilapidated, corrugated metal building across the tracks and went into business.

At the outset, it wasn't romantic in the slightest. "This place was two inches deep in pigeon poop," remembers Fisher. "We shoveled for days. And the roof was so bad that when it rained outside, it rained inside."

A field of mustard seed glows a vibrant yellow near Churchill. Oil seed crops like mustard, camelina, canola and safflower are being made into fuel for Montanans—giving farmers and ranchers a good rotation crop, a byproduct to feed their livestock and a fuel source to power their tractors.

These days the roof is tight, the floor swept, and the innards of the building filling up with infrastructure—storage tanks and pipes, fuel pumps, grain presses, and a small laboratory. The place hums with enterprise, and both partners exude entrepreneurial optimism when they talk about their business. It's an energy that has been missing for decades in Montana's rural communities, where young people have had no choice but to move away to find work and where main streets feature more boarded-up buildings than open signs. Towns like Chester, Joplin, Malta, Inverness, Saco, Shelby—where schools are consolidating, populations aging, and the scent of economic decay is as real as the long views across prairie.

Earl's mad scientist image is only enhanced when he ushers me into the small lab along the plant's east wall. It is crammed with beakers full of amber liquid, test tubes, rubber hoses, and burners that Earl bought from one of the nearby high schools that had been forced to consolidate. On a shelf he has assembled the three ingredients necessary to make biodiesel fuel, all available in local stores. Several glass-fronted cabinets have equations and figures scribbled over every inch. A whiteboard fastened to the back wall is crammed with more calculations. Down in the lower left corner are several scrawled slogans: "Saving the World 400 Gallons at a Time" and "EFB Hosing the Middle East."

In a closet-sized room next to the lab, Earl sits down in front of a computer hooked to a gas chromatograph, which nails down the vagaries of the chemical mix he is working toward. "This is the '97 Toyota of chromatographs. It's a workhorse," he says, with the pride of a farmer showing off a favorite tractor.

"I can do everything we do in the plant on a small scale right here," he says. He goes into a quick, technical summary of some of the biodiesel chemistry challenges—stripping fatty acid molecules from triglycerides, separating water from the fuel, messing with cold-weather flow properties.

"We didn't talk much about any of this for the first eight months," Fisher admits. "We took it slow and made sure of our process first."

"We live here," adds Earl. "If we stick it to someone, we have to see them in the cafe the next day. Our kids might be in the same class at school."

"Every few years around here somebody shows up with the latest miracle crop. They get people excited enough to grow a couple hundred acres of it. Often as not, we never see them again and that crop ends up in the coulee. We can't operate that way."

Make no mistake, Earl and Fisher are asking for a commitment from area farmers, and like any business proposition, it involves some risk. They don't want to take chances with that, but they are also confident of their product and genuinely proud of the close-to-home, circular nature of their business.

A farmer signs a contract with EFB to sell them a

crop that can be pressed and processed into oil-based products, like biodiesel. EFB renders the safflower, mustard, canola, or camelina into a variety of products, all of which have the potential to be used locally. Biodiesel is their signature, and EFB has the goal of producing one million gallons of it every year at the Chester plant, a goal that requires local farmers to grow roughly 20,000 acres of targeted crops.

The first summer they were in business, Earl and Fisher closed the plant down to devote time to farming. This past summer, however, they produced 9,000 gallons of biodiesel and employed five workers. They aren't turning a profit yet, but they are breaking even as they expand, and have just bought two biodiesel pickup trucks for the business.

"Now that we have those brand-new trucks, people will really start talking," jokes Fisher.

They're working on a "cluster" of products, including edible oils for cooking, and on engine lubricants like 10w30 motor oil. The leftover "cake" from the pressed crop can be sold as livestock feed or as pelletized fuel for wood stoves. There is some evidence that the pressed leftovers might also be an effective fertilizer to plow back into the soil. All of it bought, processed, and resold in the same town—a closed loop.

"We don't have waste," boasts Earl, smiling. "We have byproducts."

At the same time, EFB has to subject their biodiesel to a battery of government quality-control tests to sell it on the market. They also have to cope with taxes on any fuel used in vehicles on the highways. Then there are the usual business challenges of building a supply base, marketing, and distribution.

"We had a meeting at the end of October with the Great Northern Growers Cooperative and other area farmers. We introduced them to our concept and business plan. We want to make it clear that we aren't trying to put anyone out of business. For example, we're using the local fuel distributor to sell our biodiesel, rather than trying to compete with him," Earl tells me. "We want to build business, not take jobs away from people."

Farmers around Chester are getting in the habit of buying EFB fuel for their combines, tractors and other vehicles, often blending it with regular fuel. Earl and Fisher are working on bringing down costs to be competitive, but even when they have to sell at four dollars or more a gallon, people are buying.

"They like the fact that it's made right here, that it's green, and that biodiesel reduces emissions," asserts Earl.

Originally, Earl and Fisher had ambitions of producing ten million gallons of biodiesel every year, but when they calculated the byproduct they'd have to sell, they realized that it was an unreasonable expectation. Instead, they're hoping that once they get their plant running at full capacity, they can build additional

facilities scattered across the region, and keep multiplying the "keep-it-local" model.

The EFB plant showcases a movement taking place in the rural West, an evolution of agriculture and value-added products of which Montana seems to be on the leading edge. From garage-scale biodiesel "factories" to multinational corporations contracting for crops like camelina, alternative energy has evolved from a catchphrase to a substantial business force under the Big Sky.

"Montana is the poster child for camelina in the United States," says Don Panter, president of Sustainable Oils Company. Camelina is a grain that has been grown for millennia in Europe, but is relatively new to North America. Panter's company is promoting camelina as a fuel crop in Montana and other western states. He touts camelina's role as a rotation crop and a grain that will grow on relatively unproductive ground. In 2008, his company sold contracts for 25,000 acres of camelina in Montana, which was harvested and shipped to processing plants to make biodiesel fuel. Sustainable Oils has increased its contracts in the year since.

Great Plains–The Camelina Company is also promoting the grain in Montana, and has plans to build several crushers and refineries around the West, with a goal of producing 200 million gallons of biofuels annually. Following more than a decade of research and testing, Great Plains has manufactured ten million road miles of camelina biodiesel. Their goal is to reach 100 million gallons by 2012.

Montana State University-Northern, in Havre, has opened a Fuel Certification Lab on campus with the equipment and staff to run quality-control testing on biofuels generated in the region and to assist in the development of alternative energy businesses.

"This sends a signal," said Montana Governor Brian Schweitzer at the lab's opening ceremony in March of 2008. "We will grow, produce and consume our own fuel domestically."

While some big corporate players in the biofuels world are finding Montana an attractive business environment, Earl and Fisher underscore their commitment to the community, and to a stake in the future symbolized by their young children. They visit classrooms to demonstrate making biodiesel from store-bought ingredients, and to show how cleanly biodiesel burns compared to fuel bought at the gas station. Every weekday several groups of high school students troop up to the EFB plant on a school-to-work program and get plugged in to the enterprise.

"It's pretty fun when you hear a fourth-grader say they want to be a chemical engineer and make biodiesel when they grow up," says Earl. "Or when you see these high school kids getting excited about being green."

All along, the key has been to infuse the local economy with the prolonged fruits of the business. Chris Decker was EFB's first full-time employee. He grew up

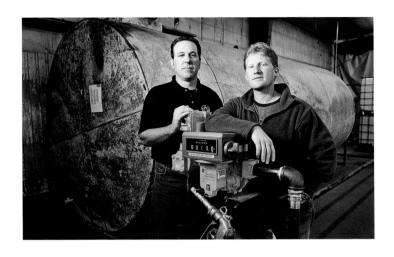

on a local farm, but couldn't find work after graduating from high school. He served two tours in Iraq, got married, and wanted to come back to Chester. The job at EFB finally allowed him to do that.

"I know just enough to mess something up," he jokes, but it's clear that he takes the work, and the opportunity, very seriously.

"Look, if we can expand enough to hire ten workers," says Fisher, "that's potentially ten families that can live in this town. In a place like Chester, that's a significant number. Hell, two people staying here is significant! Those are kids who keep schoolteachers on the payroll, people who eat at the local restaurants, families who use the library and shop in the grocery store and make doctor visits. Around here, ten jobs is huge." ∂

Top left: Brett Earl and Logan Fisher, Earl Fisher Biofuels, Chester.
Above: Diesel made from petroleum sends up a black, sooty stream of smoke while biodiesel burns clean.

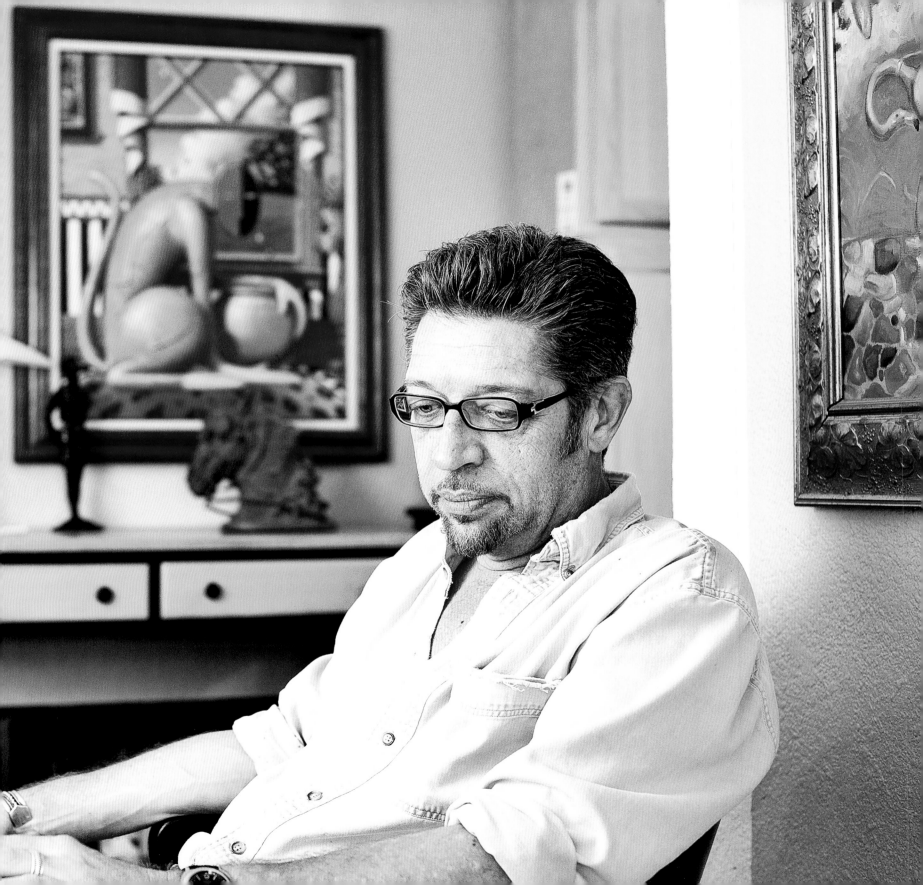

The Serial Art of Jerry Cornelia

RED-HAIRED WOMEN, NO EYES & TRUE HORSES

In 1985, when Jerry Cornelia made the leap from his home town of Sidney to New York City, he wanted nothing more than to be the best mannequin painter in the business.

"I loved that job," he says. "I pestered them until they hired me, then I got really good at it. I practiced at home after work. I painted so hard I had to soak my arms in ice every night."

Cornelia loved the finite tangibility of the work. One mannequin at a time. Do the job, set the figure aside, move to the next one. Jerry figures he painted upwards of 17,000 mannequins. He got fast. He got good. He got noticed.

"After a while I was asked to do some big gigs. Mannequins for Saks Fifth Avenue, Christmas displays, shows for Calvin Klein. Hell, I made enough money for the down payment on a house on Long Island in one three-day weekend painting mannequins and doing displays."

Then some big name trendsetter decided that mannequins were out of fashion and demand went off a cliff. Cornelia was abruptly laid off, then briefly hired back as a mid-level manager.

"Problem was, I was much better with mannequins

Jerry Cornelia at his home in Sidney.

than with real people," he remembers. "Quality control was a bitch. I was too much of a perfectionist."

In short order he was another starving artist in an expensive city. He sold his sculptures on street corners at ninety dollars a pop. For a while he made fancy, hand-painted birdhouses adorned with architectural details Cornelia picked up at antique shows and flea markets. Some were showcased in Soho art galleries and sold for six to seven hundred dollars. "People would spend six hundred bucks on an artsy birdhouse and then nail it to a tree in their yard," Cornelia shakes his head. "Now that's a different take on money."

He moved in the currents of big-city energy and creative buzz for a decade before his father, back in Sidney, got sick. Cornelia mentioned the possibility of moving home to help out and his parents jumped at it. In 1995 Cornelia returned to the small town along the Yellowstone River where he'd grown up. He returned to sugar beet fields, oil rigs, friends he'd gone to grade school with, sweeping skies and winter blizzards. A town where art boutiques are as scarce as sushi, where neighbors drive Dodge Rams and ride horses and would no more pay six hundred dollars for a bird house than show up naked for work.

"I didn't know it at the time," Cornelia says, "but when I moved back I bought my freedom. The only thing I really miss about New York is the great food."

"In New York the energy is a force in the air, like weather," Cornelia admits, "but it is also very confining. Everyone is in their little box, their limited genre. Out here it's a void I have to fill, but there is no one telling me what I should be doing, either."

———

The other surprise is that Cornelia's art, with its persistent detours into the surreal and absurd, has more to do with the influences of a childhood in Sidney than with his tenure in New York. Influences like the fact that his father was the town sheriff and the Cornelia house was also the jail. That Jerry had to go through the women's cell in order to get to his bedroom.

"Whenever we had a prisoner, I had to drop down through the trap door in the kitchen, go through the basement, and pop back up in my room," he recalls.

He would serve breakfasts, cooked to order by his mother, to the inmates. Cornelia remembers the exquisite irony of delivering a breakfast tray to one of his teachers who had been picked up the night before on a drunk-and-disorderly charge.

"Those were my Opie years," Cornelia laughs, although he's the first to admit that his childhood was less than Andy-of-Mayberry innocent.

"Sheriff's and preacher's kids are always the wildest," Cornelia claims. "I remember getting drunk with the preacher's daughter up in the church balcony. Who was going to catch us there?"

One of his early mentors was an uncle who lives out near Jordan, and who was in tight with the Freeman bunch.

"He knows all those guys," Cornelia says. "He may be a little whacky on the political side, but he showed me a lot when it came to painting."

Cornelia's grandmother was also artistic, and his father had hidden talent that was overwhelmed by the demands of a life that required him to quit school after eighth grade to work on the family farm.

Cornelia's creative appetite flourished in spite of the fact that he grew up in a cultural backwater without art schools. From an early age art bubbled up from his inner well. At the age of five he painted circus wagons on big squares of paper he taped to the walls. He doodled eyes on the margins of his schoolwork, a practice that probably didn't hurt when it came time to paint mannequins. To this day, besides a couple of night courses, Cornelia has no formal art education. He remembers other, more pragmatic, limitations.

"Paper was precious when I was a kid," Cornelia says. "I don't know why my parents couldn't just go buy a ream. How much could that cost? But I had to scrounge paper wherever I could. I remember what a score it was when people gave me pieces of that great, shiny cardboard from store-bought shirts."

That resourcefulness fueled Cornelia's art projects

through the decades, and it is reflected in his willingness to experiment and explore. His artistic sweep runs the gamut from chicken neckties to painted roof shingles to sculpted busts mounted on antique piano legs. He tends to stick with series. As for technique, he finds his way as the problems present themselves.

His "Coco" series was inspired by a friend with that nickname who died of AIDS. Then there's "The Adventures of the Yellow Ball" series, paintings with a yellow rubber ball somewhere in the frame. After his fancy birdhouse phase, Cornelia had a fling with painted clocks.

"I'll get an idea in my head and then I just keep trying different ways to make it happen," Cornelia says. He points to a painting, one of his "cat series," set in a scene full of shiny marble. "Mostly I wanted to see if I could make marble glow."

"And I steal styles from the best of them," he asserts. "When I see something I like, I use it. The way the light comes from the upper left in a Rembrandt, somebody else's trees, whatever."

"I can't stand the artsy-fartsy talk," Cornelia shudders. "All that conceptual art crap should be left on the cocktail napkins it gets doodled on. It tires me out."

While he has little patience for the pretentious themes people read into art, Cornelia is completely serious about the mechanics of his work—the way light illuminates a scene, the touchy business of balance in a composition, the set up of negative space. His paintings radiate a crisp clarity, an attitude, a unique mix of me-

ticulous reality and existential juxtaposition. They jump at you, pull you toward them. His sculptures are rich with nuance—a beautiful woman's face, the curve of a horse's neck, the sense of motion frozen in momentary check. And never far from view, his deep awareness of the absurd and comic, even in the most serious subjects.

After Cornelia's father died, his mother's health declined. She suffered from Alzheimer's disease, and eventually had to live in an extended care facility, where she existed in a netherworld of paranoia, out of touch with family, without memories or bearings, frustrated and angry much of the time. Cornelia painted a portrait of his mother wearing prison stripes, an old lady with anguish and anger beaming from her like heat, leading an uprising. The painting is titled, *Little Fay Seemed an Unlikely Candidate to Lead the Revolt*.

Most of his pieces bear lengthy, irreverent—and sometimes R-rated—titles. "Relationship angst makes for really good material," he laughs.

A painting of a blue-haired man/monkey with an apple held out in his hand is titled, *The Time had Come for the Blue Monkey Boy to Make up his Mind*. A painting of a squat, pugnacious-looking dog in a tight, studded collar reads, *Fuck Purdy…I Got Personality*.

"I've been doing a set of candlesticks with titles so long they're like short stories," he says.

"I think it was Tina Turner who said that you either gotta be best, be first, or be different," Cornelia adds.

In the case of much of Cornelia's art, you'd have to check all those boxes. And yet, he makes it sound like

his successes are happenstance, more of a right time, right place thing than a measure of his skill and vision. Like anyone's birdhouses could end up in art galleries in Manhattan, or as if he just happened to be in the right place to get the jobs with Saks.

But it didn't come easily when he first returned from New York. Cornelia was healing from a relationship breakup. His father was dying. He didn't have a studio. He spent months getting his bearings, reacclimatizing.

He eventually got a studio organized in back of his grandmother's old house and his productive energy kicked in. Years of paintings and sculptures piled up. He got picked up by galleries, recognized around the country. Then a faulty valve in a propane tank blew and his entire studio burned to the ground.

"I lost sixty paintings and sixty sculptures," he says. "I remember going back in and sifting through the ashes. One of the only things that survived was a notepad with the words 'Shit Happens' scrawled on a page."

After the fire, Cornelia bought a small house north of town on a postage stamp of land. He started remodeling a mudroom into his new studio and getting back to work. Last July a freak microburst storm cell hit. The wind ripped the studio roof right off the house and hurled it across the yard. Torrential rains followed, filling up the room with water.

"I was sweeping waves of water out the door," he says. "The basement filled up like a swimming pool. That really set me back. I watched a lot of television, and I'm a TV junkie to begin with. I've finally gotten the roof fixed, got some things on the easel again, but it's still a mess. Now I've had fire and flood, I figure grasshoppers are probably next!"

Cornelia is in his mid-fifties. Eight years ago he survived a heart attack. He has thought about mortality some. He has the gravel voice of a man who smokes two packs of Old Golds a day. Except for a stud earring and stacks of silver rings on his fingers, he looks the part of someone who grew up in Sidney. Cowboy boots, blue jeans, the firm handshake, subdued waves to other drivers on the road.

He lives alone on a quiet road in a house cluttered with his art, with piano legs, spindles, and fancy details from caskets stacked on the porch waiting for a project, a fresh cat painting on the easel, sculptures on the dining room table. He doesn't like to travel, says he sucks at marketing. "Anyway, I know how I like my coffee."

"I used to be very disciplined," he says. "I worked from noon to eight non-stop. These days it's less focused. I have to make time for *Judge Judy*. Things come up. And I'm still getting over the flood."

Outside the weeping willows stir in the ceaseless wind. Two horses, an appaloosa and a quarter horse, stand in a small enclosure.

He steps through the sliding door onto the porch. "Here's my nags," he says, warmth in his voice. He walks through the gate, nuzzles up to the horses, strolls around them. Then he shakes the apple tree so fruit thuds to the ground. The horses nose them along before lipping them up.

"Expensive lawn mowers is all," he says. Then the truth comes out. "They're my inspiration."

While his landscapes and most of his animals take substantial liberties with realism, his horses are scrupulously accurate, searingly correct. They are also full of reverence. "It's a respect thing," he says. "I don't know what it is about horses, but I can't mess with them."

When it comes to deciphering the twisting path of his career, Cornelia blames the random nature of what comes along combined with a few self-imposed rules.

"Recently people have been asking me why I changed my color palette," he says. "It's because Ben Franklin in town had a huge sale and I picked up tons of a few colors. It's not about my palette, it's about me being cheap."

As for his rules, none of his paintings have actual eyes, and the startling thing is that you don't notice their absence until it gets pointed out.

"When I do eyes, that's all I see," Cornelia says. "And it just takes me back to all that doodling I did in school."

All of his women have flaming red hair. In his cat paintings the light always shines in from the left.

Rules or not, anything seems possible for the next project. Cornelia wants to get back to sculptures again. He's been thinking about some large-scale horse paintings. He is working on a chrome-coated cat, mostly to see if he can pull off the effect.

"The thing I'd really like," he says, suddenly, "is to see one of my pieces on the *Antique Road Show*. I'm waiting for that. But with my luck it'd end up being one of those damn chicken neckties. I know they're coming back to haunt me!"

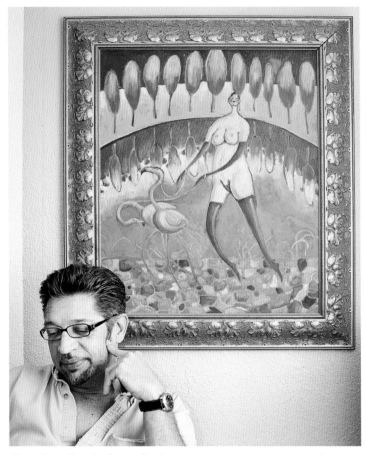

Cornelia reflects in front of And every morning Coco would walk her dogs on the North Shore of Lake Calhoun wearing nothing but attitude and evening clothes and Paco Rabanne... La Te Da. *Cornelia says the painting is an homage to his friend Coco, who died of AIDS in 1990. "He was a wonderfully pretentious shit and we all loved him for it," says Cornelia. "He was and is the inspiration for a lot of my paintings."*

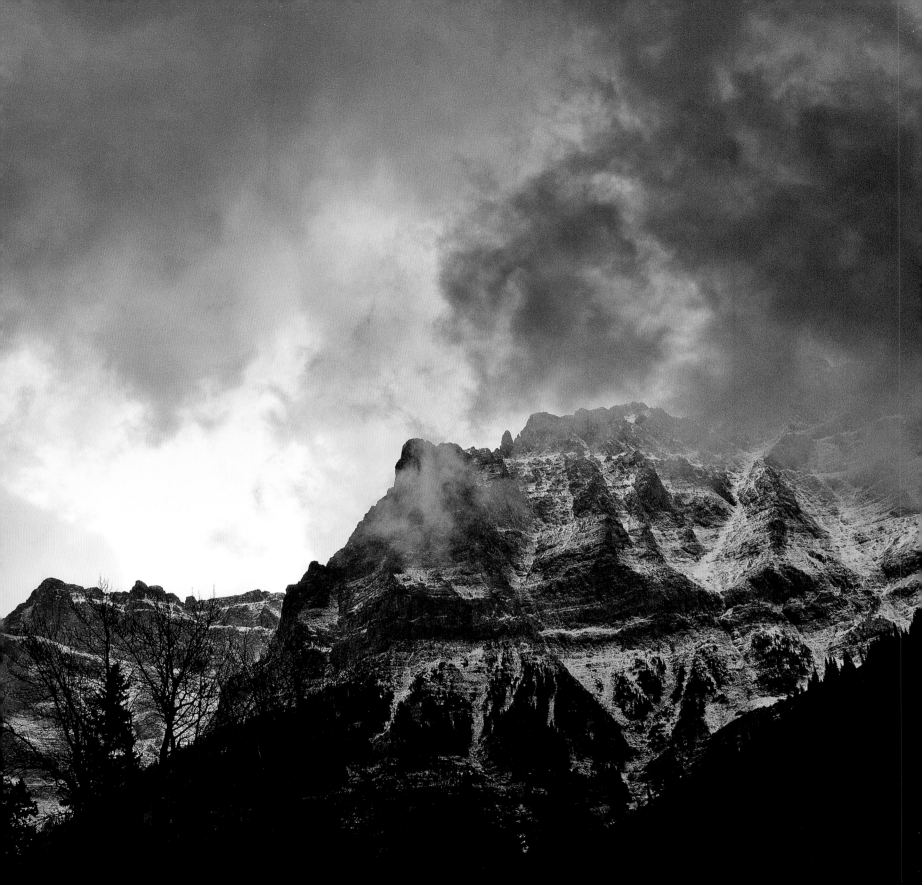

Whispers in the Wind

UNSOLVED TRAGEDIES IN THE HIGH PEAKS

On Friday the 13th, August, 1999, Joe Kampf picked up an old, weathered hiking boot lying near the edge of a glacier just below Granite Peak, way up high in the Beartooths. Inside were the remains of a human foot.

"The weather was terrible that whole trip," Kampf remembered. "It had rained steady for the day and a half it took us to get to the base camp at Avalanche Lake. We were all soaked and cold. One of the guys was a diabetic, and we were pretty worried about him."

Despite marginal conditions the following morning, Kampf and his three companions had climbed to the 11,500-foot saddle between Tempest and Granite Peaks before turning back in the face of deteriorating weather. "Big black clouds were moving in. It was incredibly windy."

Their descent took them down through soft snow on the glacier, sliding in tracks made by a previous party. Along the way, Kampf started finding stuff.

"They must have left a pack zipper open," he said. "First I found a flashlight that still worked, then a water bottle. I really started to look around. That was when I saw this boot off to the side. I yelled to the guys and went over to it.

"When I bent over to pick it up, there were the sheared-off tibia and fibula bones sticking out at me. The old sock was still in there, along with all the little foot bones. It was one of those high-top, leather work boots. I have a pair like it at home, but I wouldn't have picked them to climb Granite in."

Kampf and his partners huddled together over the find in the cold wind. "If you fell off Granite Peak," said Kampf, "you'd land right where the boot was.

"We talked about whether to just leave it there and report it, or bring it out. In the end we decided we'd better take it, but we didn't have a bag or anything. We stood there and ate our whole stash of trail mix to empty a bag."

The men built a small stone monument to mark the spot, wrapped up the boot, and hurried down in the face of a gathering storm.

"Back at base camp we waited out the worst weather I've ever been in," said Kampf. "Hail, lightning, unbelievable winds. I started to wonder if we'd brought down the wrath of God, picking up that boot!"

Two days later, from his home in Colstrip, Kampf reported the find to the authorities. He was startled by their lack of interest. "Nobody took it very seriously," he said. It wasn't until the third or fourth attempt,

Storm clouds close in on a peak inside Glacier National Park.

when Al Jenkins, the Park County Coroner in Livingston, was contacted, that someone from the Sheriff's department was finally dispatched to pick up the boot.

"That boot on Granite reopened three old, missing persons cases," said Jenkins. "There were three people who'd disappeared in the last fifty years close enough to Granite Peak to make them candidates."

It's been years since the discovery, but that investigation has still barely begun.

"It isn't a high-priority, current case," said Jenkins. The boot was sent off to an "eyelet expert" for examination, and there is occasional discussion of salvaging the necessary remains to make a DNA match, but that's as far as things have proceeded.

The most likely candidate of the missing trio is Ernest Bruffy, who disappeared in the Beartooths in August 1959. Bruffy was a forty-two-year-old construction worker from Havre who drove down to spend four or five days climbing in the mountains. A World War II veteran and skilled climber, Bruffy headed into the wilderness alone.

Several hikers who spoke with Bruffy at the trailhead reported that he planned on climbing both Froze-to-Death and Granite Peaks. They were the last people known to have seen him alive.

Bruffy's wife recalled that her husband packed himself "some salami, a small loaf of bread, a package of raisins and two chocolate bars" for the trip.

Granite Peak is the highest point in the state, a craggy prize that requires a serious commitment to claim. The approach to the base is an arduous, eleven-mile hike that gains more than 3,000 feet in elevation. The final ascent is along sheer, exposed rock that calls for semi-technical climbing skills. What's more problematic yet is that the jagged terrain in the heart of the Beartooths is a notorious, seething cauldron for storms.

We know, in fact, that Bruffy did make the 12,799-foot summit of Granite. He signed the register at the top on August 16. And there his trail ends.

One of the most intriguing circumstances of Bruffy's disappearance is that a day after he stood on top of Granite, near midnight on August 17, the most destructive and powerful earthquake in Montana's recent history struck the southwestern corner of the state. The quake registered between seven and eight on the Richter scale, was felt by people hundreds of miles from its epicenter, and essentially collapsed the side of a mountain, causing a massive slide that completely dammed the Madison River.

If Bruffy was still alive, he was presumably snug in his tent when the earthquake hit. Did he sleep blissfully through it, unawares? Was he buried by a small rockslide as he slept? If he was still exploring in the high country the next day, could he have been a victim of an aftershock or a crumbling rock face made treacherous and unstable by the earth's shifting crust?

After Bruffy's wife reported him missing, searchers combed his route for hundreds of hours. Planes flew over the area. Other than his note on top of the peak, the only scrap of evidence that turned up was a camera

lens thought to be similar to one Bruffy was carrying. The only potential evidence, that is, until Joe Kampf bent over on that bitter, wind-racked August day, forty years later, and picked up the morbid, mysterious boot.

On a bright day in early September, 1994, Scott Robinson parked his pickup truck at the illegal spot near the Pine Creek trailhead he always used, and set off up the steep trail. It was a part of the Absaroka Mountains he'd explored dozens of times, but this time he didn't come out, and not a single clue has turned up since. It is as if, on that fall afternoon, he passed through a portal between dimensions and went POOF.

"Whenever I hear of somebody coming out of the mountains with a body part, I think it might be Scott," said Robinson's widow, Shan. She has collected a whole stack of news stories on missing people and recovered remains since her husband vanished.

"It's possible Scott could have gotten to Granite," Shan told me. "He could have done it, but it's clear to me that he meant to come back out the way he usually did."

Robinson was a skilled and daring climber, driven to explore the most rugged and trackless backcountry, and he was prone to attempt difficult, exposed solo climbs with little protection. He tended to bushwhack off trail, find icefalls and rock faces, go places no one else went. On his final hike he told nobody what his intentions were. He walked in with a small, new daypack and two favorite ice axes.

"He loved to come out way past dark, hiking by headlamp," remembered Shan. "He always left a thermos of espresso in the cab of the truck as a jump start to get him home if he was exhausted."

To muddy the picture, Robinson's life was at a tenuous, stressful juncture in 1994. His first son had been born prematurely, was plagued by a series of physical handicaps, and then had died of a brain tumor the previous year. Robinson gave everything he had to Sam during the boy's short and traumatic life. After his son died, he couldn't seem to recover and go on.

"It was like he got stuck in the grieving process and couldn't move past it," said Shan. "He had become impossible to live with."

At the time of her husband's disappearance, Shan had taken her other two children and moved to Washington.

"I kept having this feeling something was wrong," remembered Shan, of that time in September. "My daughter had dreams about Scott falling. I kept calling home, talking to friends. People said he was just off hiking, but I knew something was wrong."

By the time anyone got concerned enough to go looking nearly a week had passed. Robinson's truck was still parked near the trailhead, a note under the wiper blade from the Forest Service telling the owner to move the vehicle; the thermos of espresso lay on the seat.

September snows frustrated immediate search

efforts. Robinson's three brothers arrived, set up a base camp at the trailhead, and spent a week hiking the area. Several old climbing partners visited the off-trail haunts they suspected he might have gone to. The Park County Search and Rescue people flew some of the high peaks and ridges, and let family and friends keep looking on the ground.

"He could be anywhere," said Shan. "Under a rock slide, in a bank of snow, twenty feet off the trail."

"There are places up there you could lose whole train cars without a trace," agreed Al Jenkins. "You'd think it would be pretty easy to track somebody down, but then you go up there and you think, where do we even start? Some of that terrain is like a jungle."

"Did you ever wonder if Scott meant to disappear?" I asked Shan. "If he might have wanted to start over?"

"Sure. I thought of that," she said. "But I don't think so. Everything about what he took and how he left things says he meant to come back. Besides, if he had wanted to disappear, he would have taken a picture of Sam. And he would have taken some of his most precious climbing gear. I told him a couple of times that his equipment meant more to him than his family! No way would he leave all of it behind."

"Robinson had trips planned with climbing friends, things he meant to do," said Jenkins. "But people end their lives at surprising times, when no one would suspect anything was wrong. In Scott's case, we know he was dealing with personal stress. It doesn't have to be suicide, either. He might simply have been

in a frame of mind that allowed him to take risks he normally wouldn't."

It was the following summer before Park County Search and Rescue went in on the ground looking for Robinson. By then they were searching for remains, and there were other, more pressing cases drawing energy away from the year-old disappearance of Scott Robinson.

One of those pressing and immediate cases was the third candidate Jenkins referred to, a young man named Jeremy Moors. During the summer of 1995 Moors, 24, was working at the Christikon Lutheran Church Camp, far up the Boulder River south of Big Timber.

On July 25, Moors set off into the Silver Lake and Silver Pass area west of the Boulder River in the Beartooths. He told people he planned to climb some peaks and do some exploring before returning on July 29. When he didn't come out, searchers went looking. They quickly found his camp on the shores of Silver Lake, near 10,000 feet, in the midst of remote, beautiful, little-visited terrain. His tent was still up. Moors' backpack, fishing gear, sleeping bag, and most of his food were unmolested. Apparently, when Moors left camp for the last time, he took only a daypack, water and snacks.

Several teams of searchers and dogs spent five days

working a grid pattern around the lake. Planes flew overhead. Family members came from Minnesota to join the effort. They cut Moors' tracks at several places, along with the tracks of bear and mountain lion, but nothing else. Moors left no journal, no other whiff of his intentions or state of mind. POOF!

Searchers returned for a second five-day stint to concentrate on the Silver Pass and Pyramid Peak region. On Silver Pass they stumbled across a strange and eerie manmade artifact. There on a flat boulder was a circle of bark fragments arranged around a central stone. That it had been intentionally constructed was clear. Who had done it and what it meant wasn't.

"We showed the photo of this to several Native American elders," said Jenkins. "They identified it immediately as a crude medicine wheel."

Moors was a devout Christian. He was also, it turns out, intrigued by Native American spiritual practices, including the tradition of vision quests. Moors had visited the Pine Ridge Reservation in South Dakota, and had more than a passing interest in the religious beliefs of the traditional Sioux.

The bark and stone medicine wheel lay in a direct line between Moors' camp and Pyramid Peak, a sheer and forbidding buttress that is known to have been a destination for Native Americans who went into the mountains to fast and accept visions.

Was Moors on his way to seek the modern-day equivalent? Did he build the medicine wheel? Or is it only a maddening tangent to the mystery, a meaning-less fragment with no connection to the young man on a solo journey into the mountains?

———

Moors' camp, quiet and serene and expectant, on the shores of an alpine lake nestled in wild country. Robinson's cold truck with the full thermos still on the seat. Bruffy's note in the peak register of the highest, airy point in Montana. All we have of these truncated lives, these human stories: each one with their poignant tragedies, each one with survivors left to cope with loss and grief.

And then this macabre, out-of-nowhere boot turns up at the edge of a glacier below Granite Peak. A literal fragment of a human being, a puzzle piece with no match. Hope stirs in those still waiting for news, any news. The cold trail of whispers and speculation warms.

"But then it could also be someone we've never heard of," Jenkins reminded me. "There are missing people all over the place. It could be someone who hitchhiked to a trailhead and told nobody where they were going."

Kampf agreed. "We met a kid on our hike out from Granite," he said. "He had already climbed some peaks in Wyoming. He was heading in to get to some mountains in Montana. Nobody knew where he was. The boot I was carrying right then in my pack could have been from someone just like him."

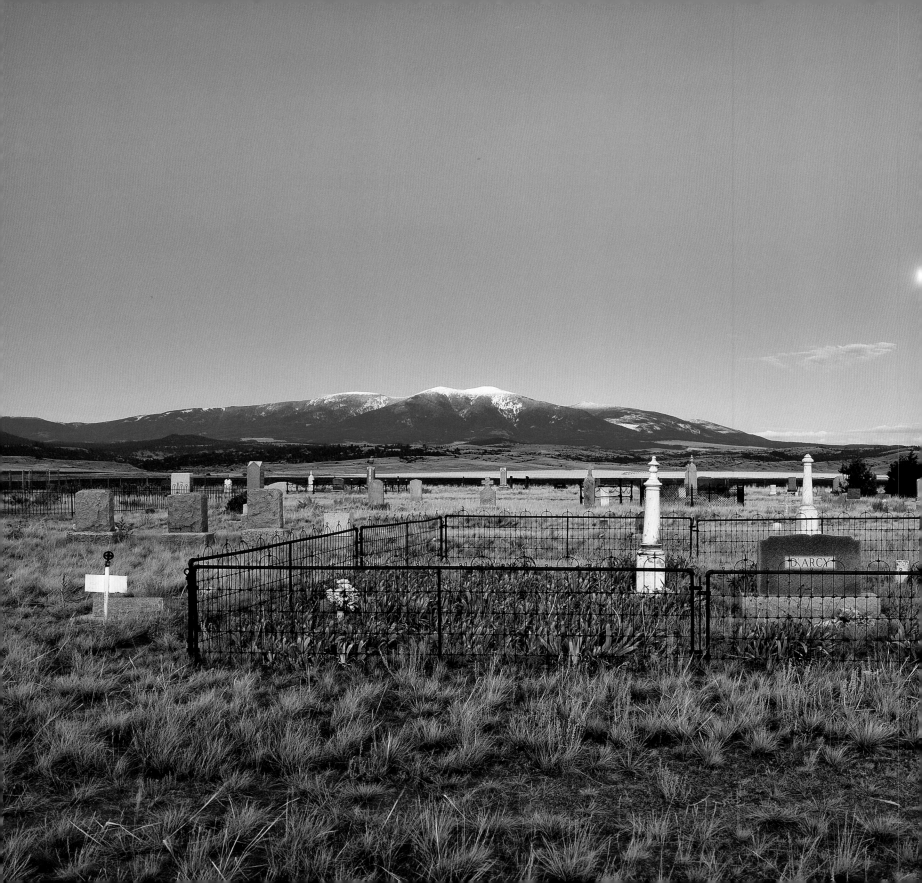

Character

PHOTOGRAPHS

The cemetery behind St. Joseph's church near Townsend is all that remains of the town of Canton, flooded by the Canyon Ferry reservoir in 1952.

71

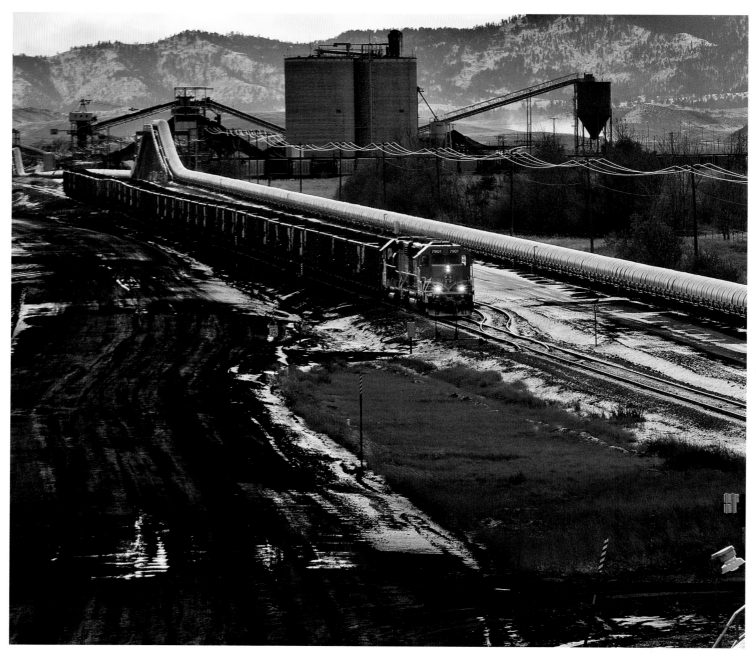

A train takes on a load of coal at the Rosebud Coal Mine in Colstrip.

Rodeo legend Benny Reynolds greets a friend at a senior rodeo in Dillon. Reynolds was the Professional Rodeo Cowboys Association Rookie of the Year in 1958 and All Around Champion of the World in 1961.

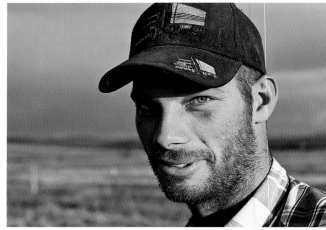

Clockwise, from lower left: Arnaud "Basco" Elissalde came to southeastern Montana from the Basque region of France in 1950. He watches over the Jordan fire hall while waiting for a cribbage game to walk in. Jimmy Ray Bromgard kisses his infant daughter at their home near Kalispell. Bromgard served more than fifteen years in prison for child molestation, then was proved innocent, freed, and won a lawsuit against the state for $3.5 million. Teddy Faber has spent his life working his family farm and ranch near Chinook. Bonnie Red Elk was fired from one newspaper for telling the truth, then started the Fort Peck Journal *and drove her old paper out of business.*

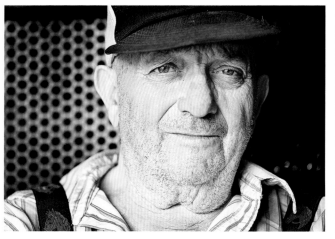

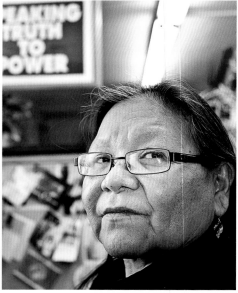

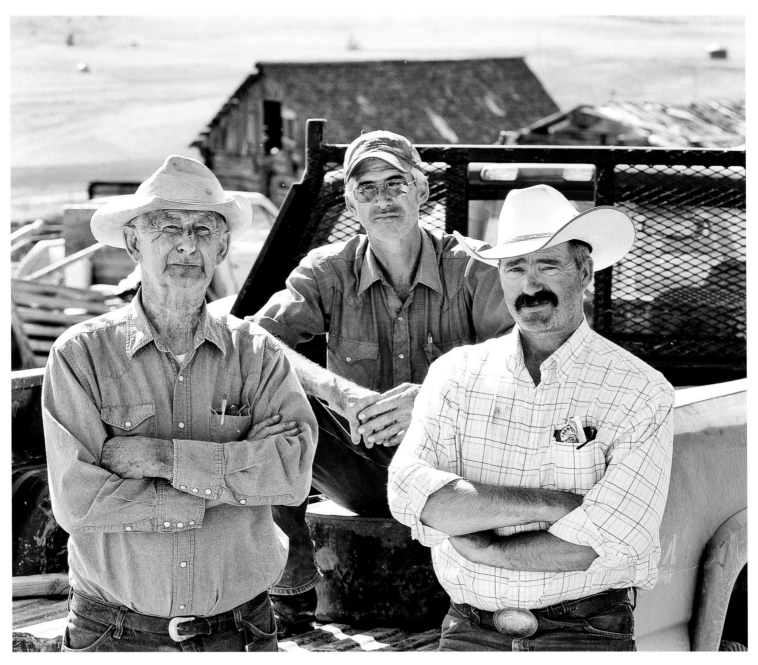

Dick Morgan and his two sons ranch along the Bridger Mountains north of Bozeman.

Diane Turko owns and operates the Stoneville Saloon in Alzada.

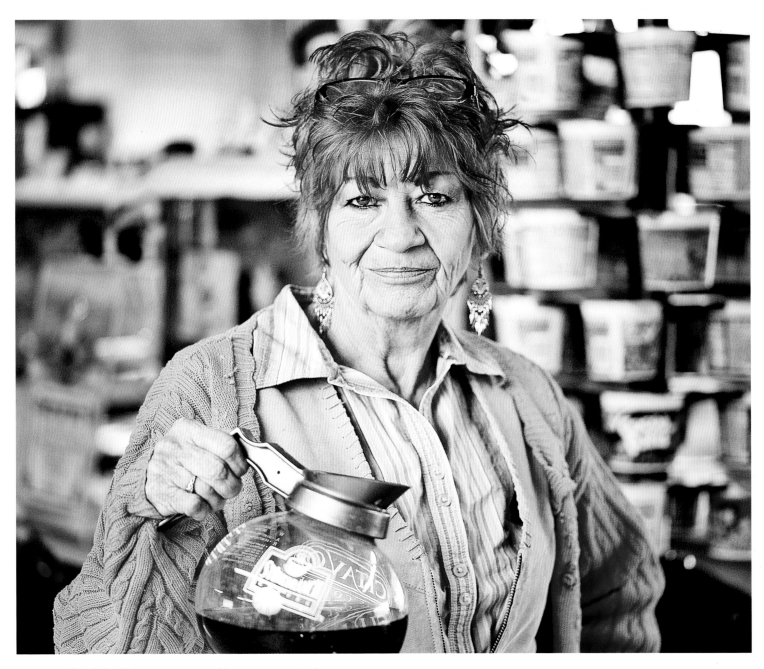

Sherry Millim behind the counter at Wade's Drive-In in Harlowton.

Summer evening basketball near a church in Chinook.

Fall football practice in Big Sandy.

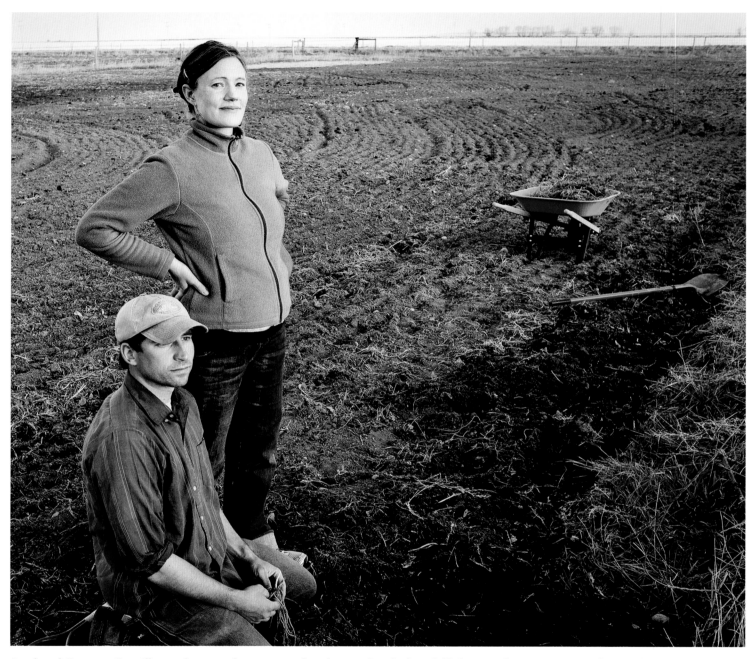

Jacob and Courtney Cowgill were three months pregnant when they posed in the bare field they were leasing near Conrad in April 2010. The Cowgills were growing organic alfalfa, lentils and heritage wheat, a rare ambition for young couples these days as farmers grow older and their children choose other careers. "We've come to terms with maybe this will work, maybe not," the couple says.

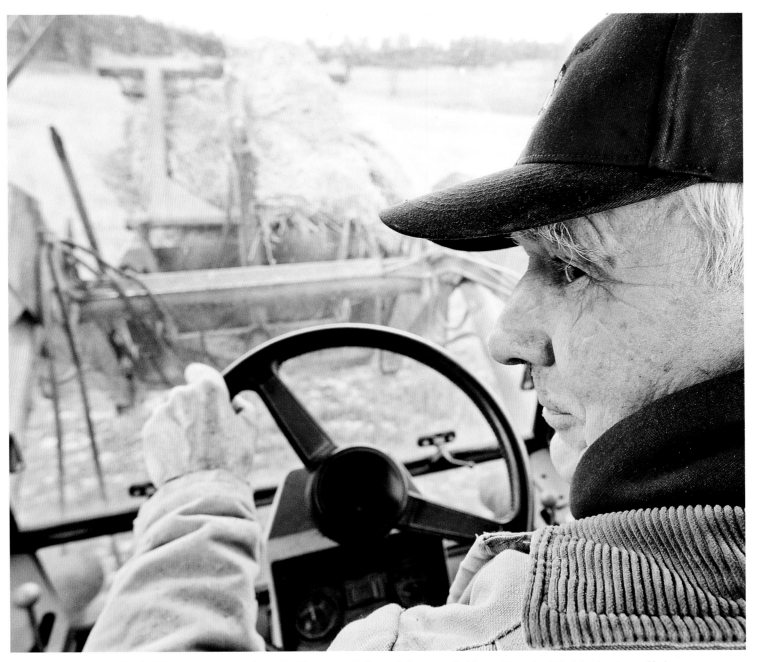

Bill Meadows drives a load of hay to waiting cattle on the Thompson Falls ranch he has called home his entire life. Meadows' grandfather E.J. Thompson came to Montana in 1884 and homesteaded on a neighboring property, Meadows says. Then Thompson bought this place in 1902.

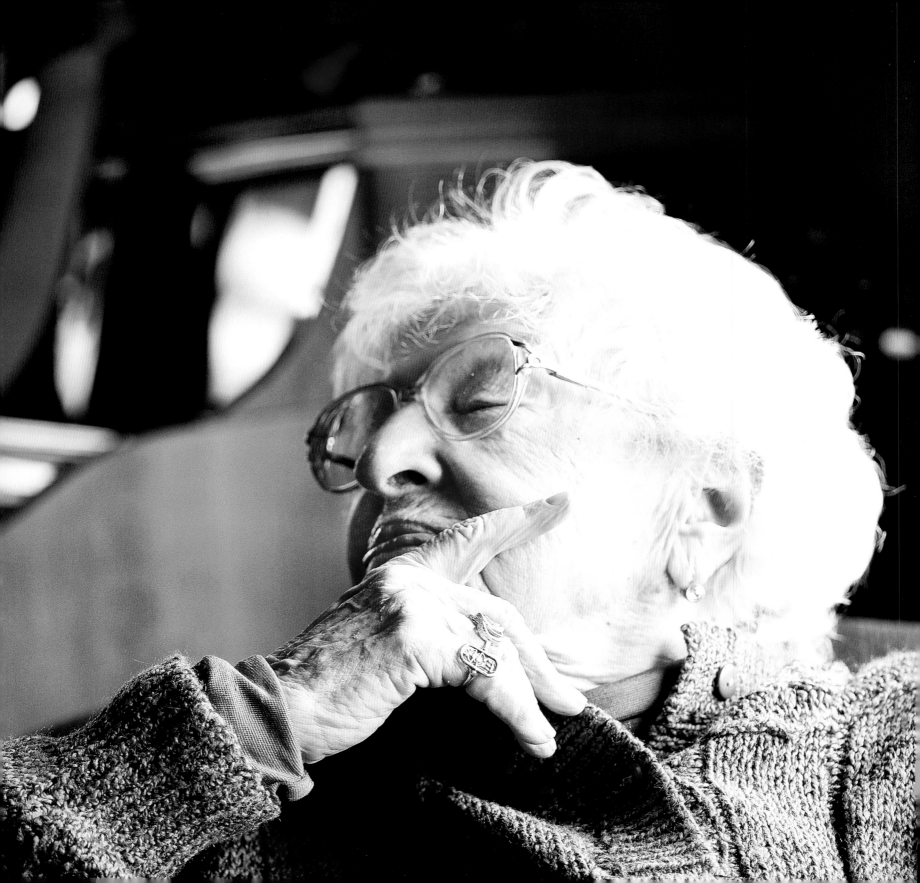

A Dangerous Woman

100 YEARS OF RABBLE-ROUSING

Elsie Fox navigates the compact living room of her trailer in Miles City. She takes small, careful steps, uses a walking stick for balance. She is nearly blind, doesn't hear well, stands barely five feet tall, but she exudes an aura of poise and integrity. She is 101 years old, and yet remains remarkably self-reliant, still living on her own. Her cat, Mia, is her only housemate.

J. Edgar Hoover, former head of the FBI, called Elsie Fox a "dangerous woman." For decades, starting in the Depression years, Elsie was followed and monitored by trench-coated agents. Eventually, the United States government built up a dossier on Fox that ran to more than four hundred pages. They knew what magazines she read, where she lived, what meetings she attended, who her friends were. Recently, through the Freedom of Information Act, Elsie and her biographer, Karen Stevenson, were able to obtain a copy of her FBI files.

"It is a source of great amusement to me," Fox admits, tapping the stack of paper with her name and file number stamped on the top page.

Elsie is giving "the tour" of art pieces she has collected from her travels, and that line the walls of her simple home. Her outfit is purple. She wears four rings

on her fingers. She still likes to put on red lipstick for public outings.

"This gives me great joy," she says, standing in front of a Siqueiros print of women in a plaza.

The art is an utterly personal collage that surrounds and embraces her, and that includes ornate metal work from her travels to Iran and China, a wooden make-up chest from Japan, a metal mask from Oaxaca, a local batik titled *Woman Flying Over Yellowstone*, Picasso prints, and "these glass flowers from Cost Plus in San Francisco," she concludes, with a chuckle.

Elsie points out the carefully stacked pile of books calibrated to grant Mia the view out the window, along with her "reader," a cumbersome magnifying contraption the size of an old computer monitor.

"Isn't it great!" she exudes, when she turns it on to reveal a block of four, tremendously magnified words in the daily paper.

Earlier, over lunch, at Stevenson's home east of town, Elsie had talked about her long life devoted to social activism. "If I had to pick a time to live, it would be the century I've lived through," she said. "I've seen the rise of capitalism, the heyday of indus-

Elsie Fox was 101 years old when these pictures was made in Miles City.

trial power, and now its decline." What she doesn't mention is that her life has also spanned the end of the homestead era, the Great Depression, both world wars, and a big dose of globe-trotting.

Fox was born in 1907 in a two-room, sod-roofed log cabin on a ranch along the Powder River, south of Broadus. Less than a generation after Custer's Last Stand, life on the Montana frontier was a hardscrabble existence. Elsie's father was absent for long periods pursuing a series of failed get-rich schemes. Elsie, her mother, Macie, and her older brother and sister lived on the ranch with her Uncle Bud. By 1911, it was clear that Elsie's father, Frank, was never going to take responsibility for his family. Macie got a divorce and became more dependent on her brother, Bud Gay, who was busy expanding the ranch.

Elsie attended the one-room Bay Horse School, a mile away across the Powder River. She rode a horse to school, and when the river was too high to ford, they crossed in a crude, homemade boat that Elsie's brother, Frank Jr., had cobbled together. The family subsisted on garden vegetables, game, and canned food.

Each fall, after Bud sold off stock, the family rode twelve miles to the store at Moorhead to buy flour, sugar and other supplies. Elsie remembers the jars full of candy and chocolates, and the once-a-year thrill of shopping for treats.

Years passed along the Powder River; years of deer-hunting, fishing, tending to the chores, growing up under the broad western sky. Even now, some ninety years later, the ranch on the Powder River is what Elsie Fox thinks of as home.

After finishing eighth grade, Elsie's sister, Girlie, went off to a boarding school in South Dakota. Her brother quit school and went to work. Elsie and her mother developed a deepening bond. They moved together to Miles City in 1920 so Elsie could attend high school.

It was a heady time. Women had finally gotten the right to vote and were enjoying liberation from social oppression. For Elsie, life in Miles City hummed with excitement. She took up smoking cigarettes, acted in school plays, and had many friends. In 1924 Elsie graduated from high school. The same year she moved, with her mother and Macie's second husband, to Thermopolis, Wyoming.

By 1926 the trio moved on to Seattle. Elsie had dabbled in college in Wyoming, worked as a waitress and maid, cooked for oil crews. In Seattle she took some secretarial night courses and found a job with an advertising agency. It was a job she held for the next fourteen years, and the start of financial independence that she never relinquished. With her steady paychecks she opened an account at a department store where she bought the first of the fashionable outfits she took such pride in the rest of her life.

Elsie thrived during the Roaring Twenties. "Ain't

We Got Fun!" was the refrain of the decade and Elsie was a young, attractive, independent woman living in a big city and claiming her share. She enjoyed dating, loved to dance, frequented speakeasies. At the same time, she was proving her worth as an employee.

Then, in the fall of 1929, the economy fell off the cliff. Over the next years Elsie's employer had to let every other worker go. He and Elsie decided how much money they could each take home every week. Elsie's paycheck also supported her mother and stepfather who were out of work.

She remembers vividly the moment she started down the path to becoming a "dangerous woman." It happened in 1931. She was walking back to the office from an errand at the bank when she came upon a demonstration. People were marching and protesting in the streets. She remembers a sea of gray people, gloom heavy in the air, along with the palpable desperation for food.

It rocked Elsie's world. How could this happen? In a few months life had gone from carefree to desperate, from plenty to scarcity.

"I remember thinking that the fish still swam in the ocean, trees still grew in the forest, and yet, everything had changed. What caused this? I was sobbing when I came back to the office. That's when I went to the public library and started reading," she said. "I asked for books on economic theory. It was then that I came across Karl Marx. The things he said made such sense to me, and explained so much about what was happening with capitalism at that time."

Then, as now, people felt adrift and uncertain. The foundations of their security had vanished. The future was forbidding and unclear. Most people hunkered down, depended on friends and family, lived day to day. Elsie Fox did that too, but she also began to take action.

"I don't know where it comes from," she said, finishing up a bowl of chili and her second slice of homemade bread. "Ever since I was very young I have felt the urge to fix things that weren't right. And I've always wanted to be in the thick of events. You see, it might look like I'm a dedicated activist, but it's more that I don't want to miss a thing. I find life intensely interesting!"

Elsie held on to her job throughout the Depression. Fueled by her self-education, she kept abreast of current events, events that alarmed and disturbed her. She watched neighbors being forcibly evicted from their homes. She saw a newsreel at a movie theater reporting on twenty thousand World War I veterans protesting for their rights—a protest that was brutally suppressed under Douglas MacArthur, Dwight Eisenhower, and George Patton.

Things were clearly not right, and it provoked Fox to do something. In her free time, she broadened her reading list to include *The Daily Worker* and *The Voice of Action*, a progressive paper printed in Seattle. She began attending meetings of labor organizers and socialists. Before long she joined the Communist Party

and became increasingly involved in demonstrations, handing out literature, and recruiting.

"I can't remember many quiet evenings at home," she said.

Most nights were taken up with meetings, classes, and planning sessions. At one of those meetings a man came up to Elsie and said that he wouldn't be returning. He told her that he'd listened to their arguments and that he agreed with them. He confessed that he had been paid to infiltrate their organization for the government, but that he couldn't do it any more.

"I'm leaving town," he told her. "You folks are trying to do something good. I won't be their stool pigeon."

Elsie looks out the window after lunch. The view from the dining room of Stevenson's home looks over a dry valley dotted with ponderosa pine, a view much like those of Elsie's childhood on the Powder River.

"Oh, these are so good," she exclaims, polishing off her second dessert bar. Karen clears the table. "You know how much I love this view, dear," Elsie says to her. "Even if I can barely see it."

Fox gazes into the austere landscape. She is quiet for a long time.

"I have always had hope," she says, finally. "I always believed that things would get better. Lately, though, and these last eight years especially, it's been hard to maintain that attitude." Her face works with memories, the gears of time slip.

"What people need to remember now is that change doesn't come from the top," she goes on. "None of the things we accomplished—the GI Bill, Social Security, unions, women's rights—came from above. They came from the people. It wasn't Roosevelt back then, and it won't be Obama now. It was the people. We, the people!" Her voice is husky with emotion. "We the people," she repeats. "That's what we have to remember."

"My message to young people," she continues, "is to be strong and courageous. You have a long battle ahead of you."

"I'm impressed with Obama," she says, "He has intelligence and a good heart, but all this money going to banks is going right down the drain. We have to accept the fact that capitalism has seen its day. We no longer have the easy resources to tap that make capitalism possible."

It is an argument that Elsie Fox has been refining for the better part of her life. First in the meetings and streets of Seattle during the Depression, and later, when she moved to San Francisco and World War II broke out. There, she landed a job as a dispatcher with the National Maritime Union. For the remainder of her working life she held positions with union organizations on the San Francisco docks. For decades she managed union issues, helped with protracted strikes, focused her practical and visionary energy on social

causes. With her blend of moxie and certitude, she took on government agents and corrupt union officials alike. She remembers being followed home by one of the "trench coats" after a meeting one evening. He hurried up to her and asked her to stop and talk. She looked him in the eye and said, "I don't talk to strangers on the street," and continued on her way.

———

While it isn't a relationship Elsie has many fond memories of, she was married for twenty-eight years to Ernest Fox. Elsie met Ernie while volunteering in the office of *The Voice of Action* in Seattle. He was a handsome sailor and a dedicated Communist. Although their relationship was stormy, and Ernie battled with alcoholism, it was a romance intertwined with social activism and political peril.

Ernie made no secret of his active membership in the Communist Party. He was also a German National. During World War II, Ernie was held in internment camps for three years, along with thousands of Americans of Japanese, Italian or German descent. Elsie worked doggedly to appeal his sentence, finally getting him free just days before he would have been deported to Germany, where he would almost certainly have been killed.

Later, during the 1950s, Ernie was caught in the net of the McCarthy hearings and for a second time had to endure protracted trials and imprisonment before being

released. Elsie was targeted by the McCarthy forces, too, but avoided being brought in.

When the Soviet Union revealed itself to be a totalitarian regime that fell far short of its socialist ideals, it was a "crushing disappointment" for Elsie, but it didn't shake her fundamental understanding of the issues. However, that failure of political promise, coupled with Ernie's death in 1963, and the building fervor of anti-communist vitriol in America, pulled Elsie into an uncharacteristic quagmire of depression as she neared retirement age.

While her commitment to Democratic Socialism never wavered, and in fact continued to deepen throughout her life, she stopped attending meetings and taking part in protests. She went to work, stayed home at night. Her vibrant social life waned. What brought her out of it was a budding love of travel, which began on a short fishing vacation to Mexico.

After mandatory retirement in 1972, Elsie used a chunk of her savings to book a seventy-two-day bus tour from Nepal to London, taking in Iran, India, and Afghanistan along the way. She reveled in the slow pace of the tour. "We spent five days at the Taj Mahal alone!" she remembers.

In 1973, buoyed by her exotic travels, Elsie Fox returned to her native Montana and settled in Miles City. The move to a small town well removed from the hubbub of political activism did not signal a quiet slide into old age. In order to retain her independence, and at the age of sixty-five, Elsie took her driving test

and got her first license. Her yellow AMC Gremlin quickly became a Miles City icon.

Elsie didn't need a quirky vehicle to gain notice, or to stay engaged. She joined a statewide senior citizens organization, testified in Helena to expand medical care, worked for reforms in nursing homes. She kept taking trips to Europe and Asia. She wrote impassioned letters to the editor, visited the ranch along the Powder River, went shopping at her favorite dress store in nearby Terry, rode in a motorcycle sidecar in a Miles City parade behind a banner promoting political action as a prescription for long life—"Elsie Fox is Proof!" the sign read.

She was the keynote speaker at a Mother's Day rally in Bozeman in 2006, where she reiterated her refrain of "We the People!" to an appreciative crowd. In 2007, her hundredth year, Elsie Fox received the Jeanette Rankin Award in recognition of her century of achievement. These days, she still swims regularly at the local pool, only recently gave up bridge due to her loss of sight, and regularly attends "open mic" night in Miles City.

Back in her trailer, late in the day, Elsie concludes her art tour. She sits on her couch near the window, holds her walking stick in front of her with both hands. She looks around at the things she has collected, then closes her eyes. Her breathing slows. It has been a long day. This dangerous woman recedes into her inner space, seems to sink into her couch.

Her life scribes its way back across more than ten decades—a run that meanders from a sod-roofed shack and riding bare-back behind her sister to school, from the glitter of once-a-year candy in a jar and rabbit stew with canned garden vegetables, to contemplating the staggering intention of the Taj Mahal and watching sunsets over what was once the heart of the Persian Empire. Her course spans flappers and empire-builders, dock strikes and red-baiters, the poisonous venom of McCarthy and the uplifting hope of Roosevelt. She has firmly identified the shimmering mirage of capitalism and knows in her marrow that the bank bailout of our day is good money pouring down a rat hole after bad.

Her life has been both simple and profound, grounded and elevated. She knows that it ebbs now, nearing the end. She wishes she could see around the next bend, and yet she has no regrets.

Then she rouses herself, sits up straighter, opens her eyes. "My favorite thing, these days, is to sit on my porch in the sunlight," she says, abruptly. "I love to sit there and think. There is so much to think about. Then, if I'm really feeling adventurous, I might just take off around the block."

She laughs at the thought, but no one in the room doubts the possibility. ∂

Fox stands outside her Miles City home.

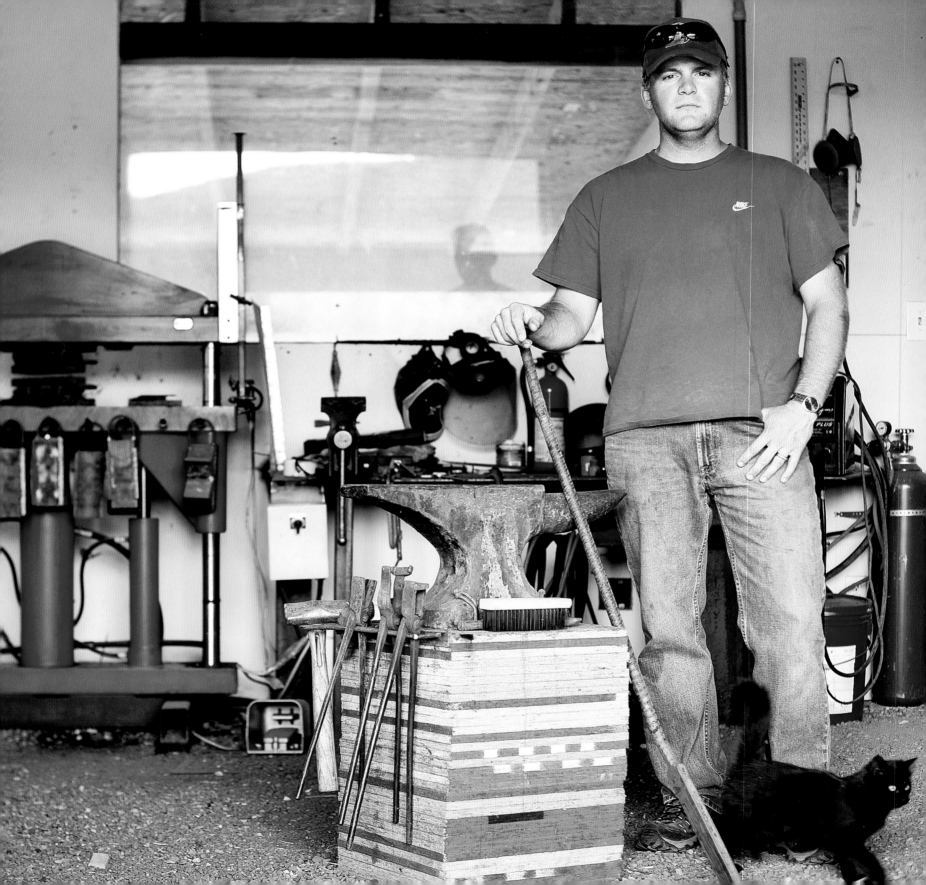

Blade Master

Apparently, Josh Smith never paid much attention to any wait-till-you're-old-enough advice. He fashioned his first knife blade at the age of eleven, earned his Journeyman Smith status at age fifteen, and at nineteen was certified as a Master Smith, the youngest in history.

By his mid-twenties, Josh Smith had established himself as a national leader in the knife-making field, a prodigy who has matured to carry forward the traditions of his craft. Precocious doesn't quite cover it.

So, when a sheik from the United Arab Emirates called with a job offer for Smith a few years back, he took it in stride.

"Actually, I didn't take it seriously," he said. "I got this email out of the blue from a guy who claimed to be the sheik's bodyguard. Will you consider building a sword for a friend? I sent some blade samples, but I didn't pay it much attention."

A few months passed. Another email, this time with pictures attached—a sword from the Wallace Collection in London that the "friend" wanted Smith to pattern his new blade after, along with an offer to fly Smith to England to have a look.

"It was only then that it became clear that this was

real, and who I was dealing with. And that was when I really started panicking. I didn't even have a passport. I had to contact Senator Max Baucus and talk his office into getting me a quick document so I could travel."

Even so, Smith didn't know how genuine this all was until he arrived in London and got into the sheik's limo.

"The sheik is actually a very regular guy, very easy to be around, and he was two hours late. He just happens to be part of a royal family with a great deal of money. But he could walk into a baseball game here in Frenchtown, Montana, and you'd never know it."

Smith visited the museum with the sheik, studied the elaborate, eighteenth-century sword set with gems and augmented with gold ornamentation, talked the project over at length.

"It was an unbelievable piece of art," Smith said. It was also a challenge in steel he couldn't resist.

"Back home in my shop, it took me three months just to make the first practice sword," Smith remembered. "That sword is a part of Islamic histo-

Josh Smith in his Frenchtown shop.

ry, made in the Damascus steel tradition. I was to create a replica, and it felt like a large responsibility."

As it turned out, the first sword was only the beginning. The sheik is interested in re-creating a number of historic blades and other military products. Smith has flown to Turkey to do research, and taken on commissions for several additional swords.

"The next project is a set," Smith said. "A sword, dagger, and battle ax. Kind of a far cry from my first little knife."

———

Josh Smith grew up in Lincoln, where his dad runs an excavation company, and where both of his parents encouraged Josh in his knife-making interest. Maybe knife-making doesn't rank high on most parents' aspiration charts for their youngsters, but in Josh's case, it was a clear and pure passion that his folks went along with.

"It was my Little League coach who got me started," Josh recalled. "He made knives and I thought that was pretty cool, so he invited me up to his shop and helped me get started. That was where I made my first blade. From there I started apprenticing with him and it just kept building."

"I think my parents saw it as something that would keep me busy and out of trouble," Smith mused.

In Smith's case, it was clear from the start that his passion was artistic. It wasn't about making weapons; it was about creating beauty in steel.

"When you see an artistic knife," Smith said, "you don't think violence. Your first thought isn't 'Wow, what a weapon!' You think, 'Wow, that is really beautiful.' I really like the fact that knives are functional as well as art. You can open letters with them, butcher meat, but they can also be displayed alongside a sculpture."

Smith never expected his hobby to become his career. His parents helped him pick up the blade-making equipment little by little. He made money for tools by mowing lawns. With his dad's help, he built a lean-to workshop next to the house, where he had to stand on a plastic milk crate to reach the grinder. His parents bought him his first knife, forged out of chainsaw chain, which led him to explore the limits of crafting his own steel for blades. He took to knife-making the way other boys took to sports or hunting, and he impressed people along the way.

Still, when he went to Montana State University he took courses in construction engineering and business finance. He moved back to Lincoln and worked with his father in the excavation business. Eventually Smith struck off on his own, moving to Missoula, but excavation remained his career path.

He built his own house on a piece of land in Frenchtown, moved in with his wife, Jodi, and continued the excavation work. But knife-making wouldn't

let him go. Seven years ago he made the leap of faith all freelance artists confront at some point. Take it seriously enough to commit to it, or relegate it to an interesting sideline, like stamp collecting or trophy hunting. Do it now, or forget about it.

He leapt. Smith started building blades full-time, developing his style, refining his products, putting his work out in the world, and hoping, somehow, to make a living doing it.

Drive by Josh Smith's modest, one-story home, in a nondescript Frenchtown subdivision, and you'd never guess that there was an artist hammering out Damascus steel and replicating Islamic swords up the dirt driveway. His workshop is in a garage across the drive from his house. There is nothing ostentatious or extravagant about the operation.

He does his design work in a room the size of a large closet. Metal chests hold drawers of walrus ivory, fossilized mammoth tusks, African blackwood, brass and steel rivets, and the other ornamentation that go into his products. Through a door sits his "dirty room," about the same size, crammed full of grinders and sanders and polishing wheels. In the dirt-floored bay next door, Smith has collected the steel-making essentials over the years. His grandfather's anvil, his forge, a hydraulic press, iron tongs, hammers, the stuff of blacksmith shops. The entire enterprise would fit into a two-bay garage.

"I try to make products across the spectrum,"

Smith said. "It isn't every day you get Islamic sword-making jobs. That's a once-in-a-lifetime business opportunity. So I make everything from pocketknives to historic replicas of the original Bowie knife."

What's surprising about Smith, given his youth, is his dedication to the history and culture of blade-making. He has lofty ambitions and exacting standards, but it is very evident that ego is not what drives him.

"My goal is to become one of the best knife-makers in the world. I figure that will take me most of my life, and I would never be where I am today if it weren't for all the craftsmen that came before me," he said. "Knives were man's first tools. We're rebuilding and refining ancient designs."

Smith means it when he uses the word ancient. Some of the designs still being tweaked were first chipped out of pieces of obsidian by loin-clothed artisans hunkered in caves lit by firelight; artisans dealing with the same issues Smith does—material, angles, strength, balance, sharpness, practical function, beauty. For them, a good tool made the difference between living and dying, getting the next meal, preparing a hide for clothing or shelter, cutting fuel for fires.

Smith works in greater comfort. He doesn't count on his knives for physical survival. His tools are relatively advanced and sophisticated, but the demands

remain exacting and the consequences ultimately real.

Damascus steel is one of the historical themes that Smith has committed himself to carry on. It is quite literally a convoluted form, and something of a lost art.

Damascus steel originated in India shortly after A.D. 1000 and the technique flourished, spreading to Persia, well into the eighteenth century. Although many specifics of the craft have been lost, the defining characteristic of the process involves the lamination of layers of metal to blend hardness and flexibility into hot-forged steel. The combination of metals folded together and metamorphosed under intense heat creates a grain patterning and texture left by carbon trace elements. In the hands of skilled artisans, the patterning can be exquisitely beautiful. Through careful grinding and polishing, those patterns are accentuated and fashioned.

Damascus swords became legendary in their time. They were so hard that they cut right through sword blades of inferior quality and were known to break through hunks of rock. Yet they retained an edge so sharp that they could slice through a piece of sheer silk fabric.

The sword Smith made for the UAE sheik was comprised of three hundred layers of "ladder-pattern" carbon steel. He worked it carefully at forge temperatures as hot as 3,000 degrees. No wonder it took awhile.

"You can put just about anything you want into a blade," Smith asserted. One of his Damascus knives sports a baseball diamond complete with players and outfield grass. Others have his name printed near the handle in dark steel. Much of the steel that comes out of the Damascus process is abstract and swirling, patterns as complex and individual as the whorls of human fingerprints. All of it, for Smith, echoes an art form a thousand years old, a tradition he carries on and presses forward from his unpretentious shop.

Although blade-making is a solitary occupation, Smith is dedicated to the society of blade smiths and to furthering the acceptance of his craft as an art. He attends a handful of knife shows every year, and hosts the Big Sky Country Hammer In, where knife makers from throughout North America come together at Smith's shop to teach the craft, share techniques, and raise the bar of excellence. It is a time for Smith and other artists to mentor the next generation of knife-makers, and to explore the boundaries of the field.

It can also be lucrative. "One year we had a private art show featuring some of the finest smiths in North America. We sold $40,000 worth of product in thirty minutes," Smith recalls.

While there are currently only two women who have achieved master-level certification, many collec-

Smith made this push dagger for a client in Florida. The blade is heat-blued Damascus steel and the handle is fossil walrus ivory with 18-carat-gold pins.

tors are female, and Smith's four-year-old daughter, Demi, makes a habit of hanging around her dad's shop. In the design room one of Demi's crayon drawings is thumbtacked to the wall. "I love my dad because he tickles me," she wrote.

"She's always coming to 'work' with me," Smith says. "Just recently she made her first real knife. It has a pink wooden handle and she made the steel for the blade."

She has already beaten her dad's youngest first knife mark by seven years, and I'm guessing that she doesn't get a whole lot of the wait-'til-you're-older advice around the shop.

Smith welds pieces of steel into a billet which he will then heat in the forge.

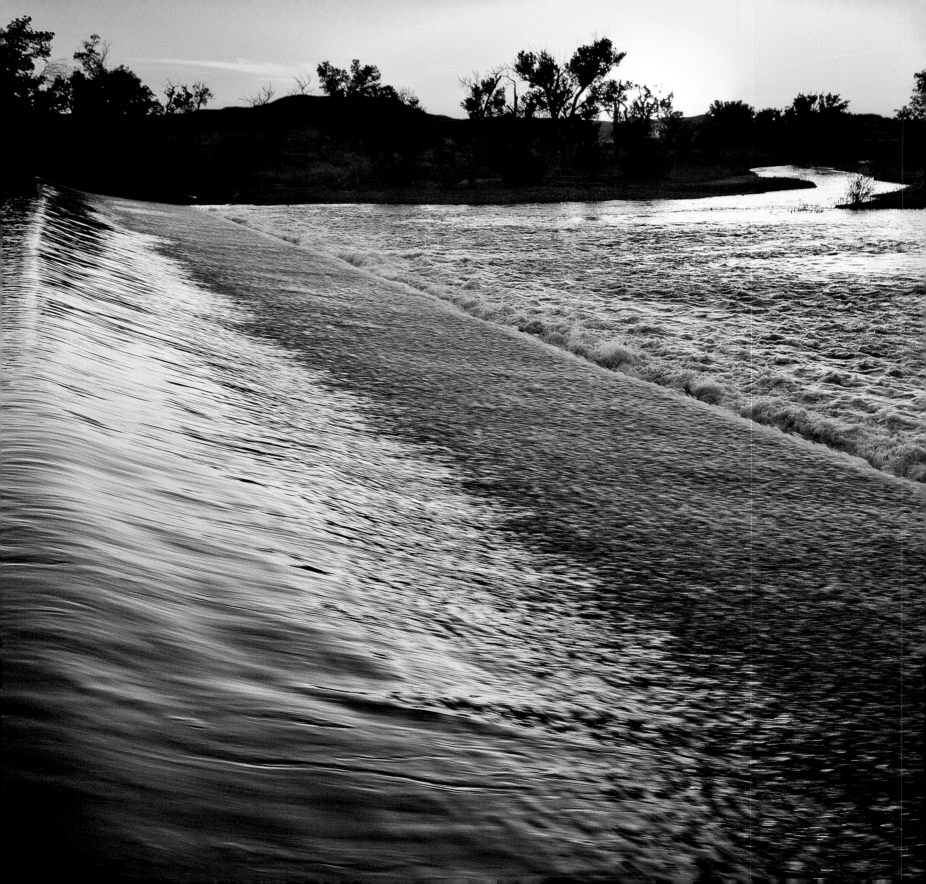

Not Letting it Die

A FARMER'S DEDICATION TO NATURE

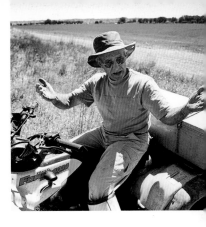

Roger Muggli is in his fields, irrigating. Where else would he be? It is June and water means everything. I catch him pulling out boards along a ditch on the land where he grew up, east of Miles City near the Yellowstone River, shifting the glittering ribbons to a new section of field. It is water from the Tongue River, sluicing down the T&Y (Tongue and Yellowstone) Canal, which he supervises, as did his father and his grandfather before him.

He is a compact, fit man, on the short side, closer to sixty than fifty, constantly in motion. When he finishes he drives over on his four-wheeler and turns the engine off. A shovel and steel board-pulling tool lay across the hood. Still astride the vehicle, he stands to shake hands, then sits back, crossing one hip-booted leg over the seat. In the sudden, warm quiet, the thirst of soil drinking up water is almost audible.

Muggli begins to talk. No chit-chat, no idle chatter; he is a man who dives in as if burning daylight is criminal.

"I've irrigated all my life," he says. "Some of my earliest memories are of being out here on the ditches."

His cell phone rings. He ignores it.

"Once, I don't remember how old I was, but I was standing along a ditch near here, watching this really big, small-mouth bass." He holds his hands ten inches apart. "We'd just turned the water so the ditch was drying up. I stood there watching that beautiful fish. It would wriggle over to some deeper water and sit there. Eventually it couldn't stay upright anymore and lay over on its side."

Muggli's hands show the fish keeling over. His face is full of the memory.

"I kept watching. The water kept drying up. The bass was gulping for air. Then I started seeing mud working through the gills, bubbling out. I wondered what that would feel like, breathing mud, lying there suffocating. I couldn't stand it anymore. I grabbed a bucket and shoveled that fish into it and ran like hell for the Yellowstone.

"When I got there I put the bucket in the water. The fish was so big it had to back out into the river. It just hung there for a while in the cool shallows, feeling the current go by, breathing, then it swam off.

"That fish has been with me all my life," Muggli looks directly at me. "How it lay there breathing mud in our ditch. Those kinds of memories won't let you go."

The Tongue River washes over Twelve Mile Dam, in front of the fish canal that allows warm-water fish to swim upstream, around the dam, for the first time since 1886.

Those kinds of memories, coupled with that kind of empathy and an abiding curiosity to understand how things work, have led to Muggli's pet project on the Tongue River, a project which you could say has taken him the better part of a lifetime to complete.

"When I see a problem, I just try things," Muggli says. "As a kid I kept finding fish in our irrigation ditches, so one time when I came across a big screen left over from a construction project, I took it on up to the Twelve Mile Dam on the Tongue and fit it over the intake on the T&Y diversion. Perfect, I thought. That'll keep the fish out.

"Then, a couple of days later I went back and saw that my dad had pulled up the screen and left it on the bank because it was all clogged up with weeds and junk. Right away I started thinking of other ways to make it work.

"I'm no different from anyone else," he says. "Maybe a little more stubborn is all."

In 1987 Muggli was elected to manage the twenty-seven-mile-long T&Y Canal, which pulls a steady 180 CFS (cubic feet per second) off of the Tongue at Twelve Mile Dam and spreads it across 9,400 acres of farmland extending down to the Yellowstone River just below his family property. It is the same elected position held by his father and grandfather, going back to 1934.

Twelve Mile Dam was constructed in 1886, a scheme undertaken by a group of Miles City businessmen to encourage agriculture in the region. It has been irrigating land ever since. It has also been obstructing and diverting, or entraining, fish ever since.

The Tongue River is one of the few warm-water, prairie fisheries feeding the Yellowstone drainage, and arguably has the greatest potential for warm-water habitat of any river in the eastern half of Montana outside of the main stem of the Yellowstone.

Matt Jaeger, a biologist working on the lower Yellowstone with Montana Fish, Wildlife and Parks considers the Tongue crucial for "both spawning and resident fish populations."

"If fish can get passage and adequate flows, it will be a huge improvement," Jaeger says. "Last year, when we had adequate flows, some twenty percent of all the spawning fish population of the lower Yellowstone went to the Tongue and Powder rivers to spawn. Some of them traveled two hundred miles to reach those tributaries."

The Powder River, east of the Tongue, is often dewatered and is more important as a spawning destination than as resident fish habitat. The Bighorn River, upstream on the Yellowstone, has been transformed into a cold-water fishery by a set of dams, and is now touted as a blue-ribbon trout stream.

The bigger picture encompasses the entire Yellowstone and Missouri River drainages, extending into the Mississippi and impacting a vast western

quadrant of the United States. Taken together, it is a significant swath of North America, much of it devoted to agriculture and commerce. Throughout, the waterways are beset by a series of major and minor dams, channelization, dredging, levees, and armored riverbanks. Free-flowing rivers are a rarity and aquatic habitat has suffered. Ancient species of fish like the paddlefish, pallid sturgeon, sauger, burbot, and dozens of others have been struggling to cope with the limitations imposed by dams and other human infrastructure. A handful of these fish species are endangered.

The prairie rivers of eastern Montana are an important piece of the larger habitat matrix, rich and productive aquatic habitats, supporting hundreds of wildlife species, from frogs to stickleback chub, but most of the fish aren't the sexy varieties featured in tourist brochures. It's a little harder to work up public sympathy for pallid sturgeon, channel catfish, and blue sucker than it is for grayling or bull trout. Call it the Bottom Feeder Syndrome.

Of course, dams and diversions don't discriminate between species, and their impact on fish is dramatic. Bottom-feeding fish are particularly susceptible to the barriers presented by dams, because they aren't natural leapers. They need smooth, laminar flows and a modest gradient to move upstream. A dam like the Twelve Mile, which imposes an abrupt wall more than ten feet high, is utterly insurmountable.

"There are about fifty species of fish that come up to the base of Twelve Mile," says Burt Williams, who works with The Nature Conservancy on management issues along the lower Yellowstone. "Species like the stickleback chub, sauger, catfish, carp, and walleye. Above the dam, there are only twelve or thirteen surviving."

For Roger Muggli, addressing that imbalance and reopening a huge stretch of potential habitat shifted from a lifelong hope rooted in childhood memories, to a full-on priority, once he was in a position to do something about it.

"After I got elected, I figured I'd get right to it," Muggli says. "I never thought it would take the next twenty years to get her done!"

———

Along the way there have been no end of meetings, financial obstacles, local resistance, and agency sluggishness. That it got done at all is a tribute to Muggli's stubborn refusal to let the project founder in the face of challenges, and to his willingness to pour countless hours of volunteer effort and significant personal resources into the job.

He may have been the only person who could have pulled it off. If an outsider had come in full of environmental fervor and scientific jargon, the whole enterprise would likely have fallen flat. Muggli, on the other hand, has undeniable local credentials and on-the-ground authenticity.

"The longest I've been away from the farm in my

entire life is two weeks," Muggli says. "I was born a Catholic and a Republican. Believe me, it's been a long, hard road for me to become an environmentalist."

What becomes clear is that long before Muggli would have identified himself as an enviro, he possessed a zeal for exploring nature and a curiosity about how things interact.

"Once our chores were done," Muggli recalls, "my mom would let us out to run. We'd head right for the Yellowstone and the hills along the banks. The only limitation was that she wouldn't let us wear shoes. I don't know if she meant to keep us from running too far, or to make our shoes last longer."

"I've watched these fish, and thought about them, since I could walk," he adds.

During the twenty-year span of Muggli's supervision of the T&Y Canal and Twelve Mile Dam, what emerged as the most plausible and reliable option for addressing the fish problem was to construct a fish-passage channel that would bypass the dam. At the same time, in 1999, he was able to get funding from the Bureau of Reclamation and Department of Natural Resources and Conservation for screening to keep fish from being entrained in the irrigation canal.

He accomplished this in typical, straight-forward Muggli fashion. When he had a hard time getting bureaucrats to listen, he started showing up in the local office with buckets of fish he found dying in the fields. A little of that seemed to go a long way.

But the fish passage was always the big project on the horizon. Even after the plan was formalized to create an arcing channel on the west side of the river, beginning well below the dam and ending just above it, the process floundered along. Funding was a problem. Heavy equipment would be needed. Skilled people would be required to work the equipment, grade the channel, and implement design specifications.

Muggli ended up donating the use of a huge backhoe, talked a friend into running it. Money was raised, roughly half a million dollars, from a medley of private, non-profit, and government sources. Stakeholder groups comprised of irrigators, business interests, state and federal agencies, and environmental groups met to hammer out compromises and cobble together a viable work plan.

Years passed. Fish continued to be thwarted in their natural urge to swim upstream. The knowledge of their plight weighed heavily on Muggli.

"It's been 120 years since fish have been able get past Twelve Mile," he stresses.

Finally, in the last two years, actual work got underway. After lunch, Muggli takes me out to view the project. We turn off the highway, drive through a ranch yard, then a corral full of milling cattle, and finally down some rutted dirt tracks to the site. It is hot and still. Dust lingers in the air.

Tell the truth, the unfinished canal is a bit underwhelming. It has just weathered an unprecedented, hundred-year flood event and the backhoe operator is

busy regaining ground and reestablishing grade along the passage. It looks rough and a bit forlorn. Still, only a few feet remain between the head of the channel and the main stem of the Tongue. It takes some imagination to visualize the finished project, which will feature a smooth, lined channel punctuated with boulders placed as resting spots for fish working their way up against the current.

"We're aiming for August," Muggli tells me. "The flood definitely set us back a few weeks. Then again, what's that when you've been waiting twenty years?"

The fish passage is the important first step in a larger, coordinated effort to open up hundreds of miles of warm water fish habitat. S-H and Mobley dams, upstream on the Tongue, are slated to be breached. Coupled with the fish passage at Twelve Mile, that will create 175 miles of available watershed habitat on the Tongue River alone.

Several other projects are either underway or being discussed throughout the lower Yellowstone watershed. The impetus for this progress has built out of the aftermath of back-to-back, hundred-year flood events in 1996 and 1997. After the floods, and amid lawsuits and acrimony, conservation districts banded together to protect their agricultural interests. Later joined by conservation groups and agency officials, an uneasy alliance has now devoted years to building enough

trust to take on a much broader view of issues.

The biggest project is taking place along the Yellowstone River below Glendive at the Intake diversion dam. Started in 2010, a forty million dollar undertaking supervised by the Army Corps of Engineers is transforming the impassable jumble of boulders into a 1,600-foot sloping ramp with a one-half percent incline and the laminar flows needed by many fish species, including the endangered pallid sturgeon. The scope of work also includes screening on the irrigation canal to prevent entraining of fish.

When the Intake ramp is completed, combined with the Tongue River projects, available warm-water habitat will extend from the pool impounded behind the Garrison Dam on the Missouri River in North Dakota up the Tongue almost to the Wyoming border, and up the Yellowstone River as far as the diversion at Forsyth.

That reach would be especially critical for pallid sturgeon. Due to a unique and unfortunate quirk in their life history, the only juvenile pallid sturgeon found here are raised in hatcheries.

"According to our latest census, there are only 136 individual pallids on this reach of the Yellowstone and Missouri rivers," reports Jaeger. "They are on the brink of extinction."

"The pallid sturgeon population is becoming ancient," Burt Williams adds. "Most of them are thirty to fifty years old."

It turns out that newborn pallid sturgeon lack the

ability to swim on their own. Rather, they float, drifting in the current, for the first two weeks of life. They have the capacity to adjust their buoyancy, moving up and down the water column to feed, but they don't truly swim. On the Yellowstone and Missouri, that two-week drift requires at least 180 miles of current. Tragically, the young, immobile pallids run into the slack water behind Garrison Dam well before they are ready, and there they perish.

As with many of the subtle environmental consequences of building a dam, no one knew about this stage in the sturgeon's life history. That species became a casualty of human ignorance. A successful ramp at Intake, however, would grant sturgeon the potential to lay eggs far enough upstream to accommodate the necessary two-week float. The rest of the warm water fish species would benefit as well.

Muggli's fish passage around the Twelve Mile on the Tongue was completed in fall of 2007 and is the poster child of the river restoration campaign. Yet, when the floods came in early June 2007, during the vulnerable midst of the construction phase, Muggli's life's work looked like it might wash away like so much pipe dream.

"I was out irrigating when the storm came," Muggli remembers. "I felt it before I saw it. It wasn't just a big,

black cloud. It was a huge black wall and it went south as far as you could see.

"When the rain came it was torrential. It just kept pounding down. We don't get rain like that around here. I watched it for a while, then I took off in the truck to start opening gates along the canal.

"All the time I was thinking about the fish passage and what was happening up at the dam. Lightning was flashing all around while I was out turning the gates. It was crazy to be out there, but I knew we were in for a huge glut of water.

"Eventually I worked my way up to the dam. Water was just pouring over, flooding everywhere. I made it around to the fish passage just as water broke through at an ox-bow bend upstream. A brown sheet of flood came tearing across the field and right into our ditch. More water than you could imagine, boiling everywhere. I thought we'd lost the whole deal.

"I started wading in to the passage to see if I could feel what was happening. I slipped in right up to my chest. The amazing thing was that it was like stepping into a can of sardines. I could feel fish all up and down my body, hitting my boots, bumping my chest, sliding past my legs. That whole flooding river was packed solid with fish.

"It was just majestic. Here were these fish that hadn't come beyond that point in 120 years. They didn't care that it was a flood. They didn't care how they went. They were just going for it, pushing up-

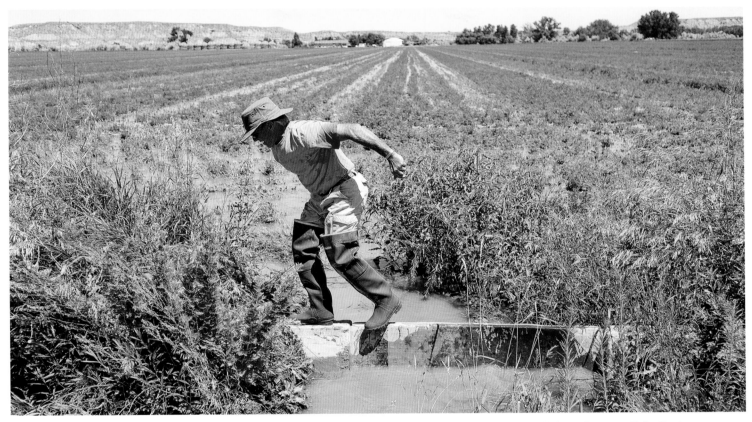

Roger Muggli stands on a small dam, shutting off the flood irrigation to an alfalfa field at his ranch near Miles City.

stream. The river was thick with them. I started shoveling fish out with my hands to see what they were. Sauger, catfish, carp, all of them.

"And you know, I thought the whole project might be a goner right there. All that work down the tubes. But in a way it didn't matter, because at that moment I knew it worked.

"The truth is that the whole time we were building, in the back of my mind, I had this little fear that it might not. You think it will. You do the studies and make the plans and include everything you can think of to make it work, but there in the shadows is this little doubt. Maybe it won't.

"Now I know for sure that it does, even in the middle of a flood, even before the channel was finished. It made it all worth it, standing there up to my chest in brown water feeling those fish pushing by, eager to go. That was majestic as all hell."

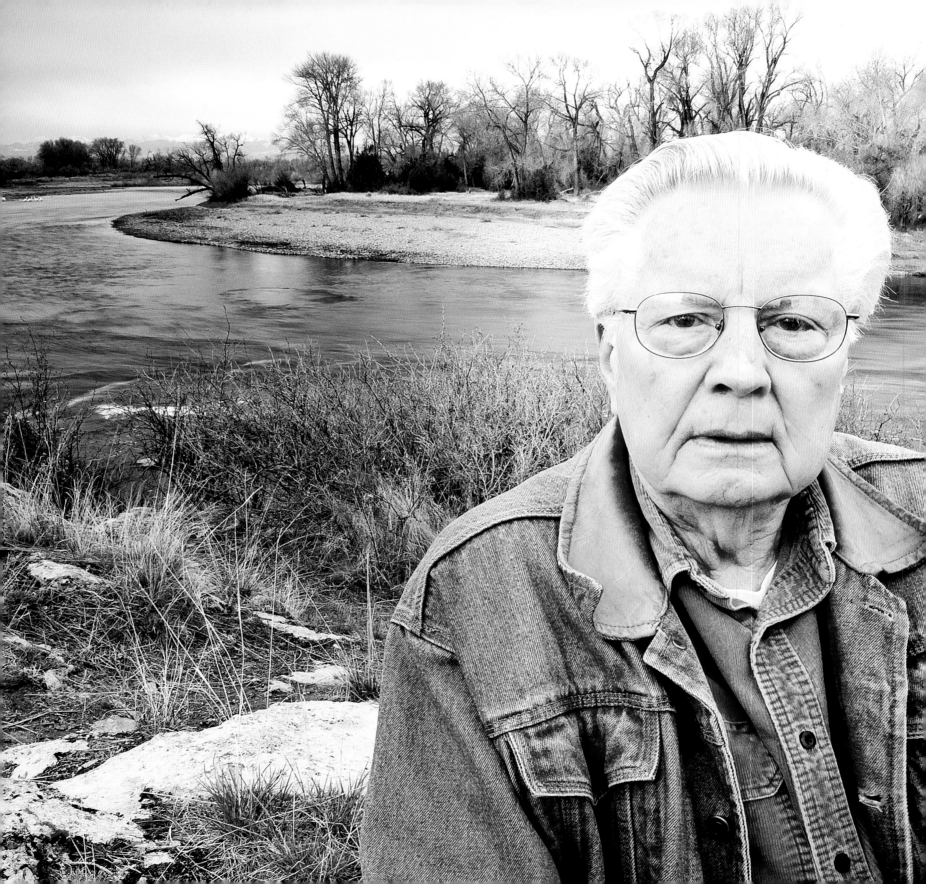

Tending the Spiritual Flame

BOB STAFFANSON'S
AMERICAN INDIAN INSTITUTE

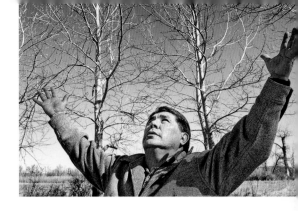

It has been more than thirty years since the first gathering, in 1977, but Bob Staffanson's face fills with the memories as if it happened last week.

"This is where the boat came." He points to the sandy beach in an eddy along the Missouri River, near Three Forks. "It ferried us right over there," he looks across to a cottonwood grove on the far bank. An osprey wheels and hovers overhead. There is some graffiti and garbage near the boat landing. Even so, as Staffanson talks, the images of people loading into a boat, settling themselves, paddling to the riverside camp spiked with teepees, come to life.

Back then, there was no Headwaters State Park. The celebration of Lewis and Clark's bicentennial was still twenty-five years off. This was a quiet, powerful place where three tributaries, great arteries, join currents to form the Missouri. Here Staffanson, a non-Indian, first brought together a group of influential, traditional elders from Indian nations throughout North America.

"There were thirty-five elders here," he says. "It was hosted by the Crow. At the time I had a vision of this place becoming a permanent headquarters, a kind of traditional Indian United Nations. That didn't happen, for various reasons, and it's probably a good thing. But

Opposite: Bob Staffanson at the headwaters of the Missouri River.
Above: Leonard Bends, Crow tribal elder.

in the beginning, my biggest challenge was to overcome the skeptics, and they included many Indians.

"That's been the story of my career. Every major project that I've taken—from starting the Billings Symphony to founding the American Indian Institute—nobody thought would go anywhere. In the early years of the institute, even the Indians were wary. 'What is this?' they were asking. 'What's the catch?' You see, they are very used to white people coming to help them, but bringing their own agenda."

It is a testament to Staffanson's authenticity, humility and commitment that the Indian elders came, in spite of their doubts.

"In the beginning, I had no preconceived notion of how things should go," insists Staffanson. "In 1977 I asked those powerful people here to connect. My motivation was, and still is, to do what I could to rectify the unspeakable treatment between cultures, to help maintain the unbroken legacy of spiritual power that is inherent in the Indian people, and to attempt to communicate that legacy to the larger society."

"I have been called a lot of things through the years," Staffanson admits. "Indian-lover. Dreamer. Chaser of lost causes. But the one I resent most is

'romantic.' There is nothing romantic or fantasy-based about what we do. It is absolutely practical and down to earth. And it has to do with our survival."

Staffanson, founder and president of the American Indian Institute, is now ninety. He spent his early childhood on a homestead near Sidney, a place with no indoor plumbing, no electricity, no car. During the Depression his family moved to the Deer Lodge valley, where Staffanson spent much of his time working from the back of a horse. At that time, many of the other cowhands were Blackfeet Indians.

"I was aware as a young man of something different in the Indian," Staffanson remembers. "Something powerful and enduring."

Staffanson was also drawn to music from a young age. He followed that muse to a degree in music from the University of Montana, and it eventually led him to pioneer the Billings Symphony. He later became the conductor of the Springfield Symphony Orchestra in Massachusetts, a position he held for fifteen years. He met and worked with some of the most influential people in the musical universe. Then, in mid-career, during a summer trip home to Montana, he was invited to participate in a Blood Indian Medicine Camp in southern Alberta.

"I was in my forties, at the height of my professional life. I was also very good at the clichés about Indians," he remembers. "I knew about the pow-wows and the dances. I had my childhood memories of running cattle with Indians. I thought I knew them. But

I had no idea. The experience was more than a wake-up for me. It was a shock. I went in one person and came out another. I saw that there is an entire reality out there that white culture does not intersect with. I saw that there was a spiritual legacy that had existed for millennia, unbroken. It is a force, an influence, beyond definition, that makes itself felt in these endeavors. It is an awareness we can not easily deal with in our culture, but within the Indian cosmology, it is completely accepted and understood."

"It took me a few years," continues Staffanson, "but I quit my career to try and communicate what had come to me. Of course, everyone thought I was crazy." Crazy or not, in 1973, Staffanson chartered the non-profit American Indian Institute and began cultivating contacts with influential traditional leaders in the Indian world.

From that crazy notion arose the first Elders Council in 1977, at the headwaters of the Missouri. This grassroots group called themselves the Traditional Circle of Indian Elders, which has grown into a yearly tradition of gatherings in different parts of Indian Country around North America. The original circle of thirty-five has grown to as many as six hundred participants at a council. Elders—both men and women, and not necessarily old in years—come together to remember the teachings of their ancestors, to carry on ancient ceremonies, discuss cultural issues, and to identify problems and threats to Indian people.

While the councils are logistically supported by

the American Indian Institute, what happens, where it happens, and how it happens is dictated by the elders. Most councils generate a Communique, a written statement issued by the elders to the world, containing an important message resulting from their meeting.

The institute has also provided funds for Indians to travel to conferences on every continent. With the institute's help, elders from the circle have addressed the United Nations on numerous occasions on topics such as the environment and indigenous rights.

The critical element, however, is that these annual councils reinforce the energy and the grounding principles of an Indian reality that have been overwhelmed by the dominant European culture, the Industrial Revolution, and the juggernaut of capitalism. In much of the world, that energy has already died away, or at least gone dormant.

"The fact that strong spiritual energy still exists among Indians is almost unbelievable. Remember, these are not political people. They are keepers of the heritage," insists Staffanson. "They are, rather, people of tremendous spiritual power, the most powerful human beings I've ever known. They have more than a shared heritage. They have connections to a world that we have lost, and access to a dimension we can't tap."

From the start, the annual gatherings have helped bring the cultural flame back to life in the host region. The first council, in 1977, was hosted by traditional Crow leaders. Tom Yellowtail, Crow Sundance Chief, and his nephew, Joe Medicine Crow, were two of the

tribal representatives. Yellowtail attended every circle gathering for the rest of his life and brought traditional knowledge back to his community from Hopi elders, Six Nations Faith Keepers, and medicine men from the Far North. It gave the Crow people a link to other spiritual leaders throughout North America. Joe Medicine Crow, ninety-eight, is the oldest member of the Traditional Circle today.

In 1988 the Circle of Elders traveled to Haida Gwaii (Queen Charlotte Islands) in the northern Pacific. There the cultural pulse of the Haida people had faded. Few of the traditional songs were sung or even remembered. Fewer and fewer individuals spoke their native language.

The elders came. They spoke of the ancient ways. More than anything, they brought back the energy tied to the traditions and beliefs, and encouraged its growth.

In the Communique generated after that gathering, the Haida stated their renewed commitment to a balance with the natural world, to the role of families in communities, to the importance of wholesome food, and to their spirituality.

In the decades since, the Haida cultural resurgence is nothing short of astounding. Of course there are difficulties—the continuing scourge of alcohol and drugs, the seduction of consumerism, the inundation of media—there as it is everywhere. But the Haida are again singing their songs, holding their traditional ceremonies, dancing in costume, carving ocean-going canoes

and totem poles, speaking their language, harvesting food from the sea, repatriating the remains of their ancestors that were pillaged from remote communities and sent to museums around the world.

This reawakening of tradition happens everywhere the elders go—the northwest coast, subarctic Canada, the Southwest, the Great Plains. They fan the dormant flames back to life, breathe warmth into the ceremonies, bring back into focus the Indian way of looking at the world. This ripple-effect phenomenon is part of the reason Staffanson is glad his original idea of a permanent site didn't work out.

"By moving each year we also reach people who will not travel, and who are important in their region," Staffanson says.

Twenty years ago, at the behest of the elders, the institute added "And Youth" to the Traditional Circle of Elders. The elders saw young people in their cultures drifting away, losing touch. The initiative was aimed at providing youth with a sense of confidence and capability to cope within a complex and often confusing world, while remaining connected to their innate cultural, physical and spiritual roots. Every year, in a different location, elders come together with youth to encourage them to follow the traditional ways, to speak their languages, to learn about sacred ceremonies, and to tell stories and play games. Again, at the core, it is about survival.

"People tend to think that Indians have this path to higher knowledge," says Staffanson. "What they have is common sense. Look, they say. If you poison the earth, if you can't drink the water, if you overuse your resources, if you stop respecting other life... you are going to suffer. The traditional Indian paradigm is holistic, based on co-existence and cooperation between human culture and nature. It holds that human intelligence is not a license, but a responsibility. In contrast, our paradigm runs on control and domination in pursuit of our selfish ends."

"Over the years," continues Staffanson, "I've learned that for the traditional people everything comes back to two fundamental themes. The first is respect. Respect for each other, and that includes people you don't agree with. That respect also extends to the other life that exists with us. The second is gratitude. A pervasive, daily thankfulness for the creation we are part of. That's it. Pretty simple, when you think about it. Respect. Gratitude."

Sure. Simple. Until you try to live it.

———

In 2005 the institute, again at the request of the Traditional Circle, initiated the Ancient Voices Cross-Cultural Forums, which are open to a limited number of non-Indian people. The purpose of the gathering is to begin a dialog around shared core values between traditional elders and the larger society. People come together to share, to listen, to learn, and then to take back what has come to them. The ripple effects are

the profound, if incalculable, consequence of the interaction.

"We can't quantify what this has done," says Staffanson. We just keep getting reports of life-changing effects. We are stimulating this energy and it has a way of spreading."

For Eric Noyes, executive director of the American Indian Institute, it comes back to something Bob Staffanson shared with him about the first gathering. "One of the elders at that meeting on the Missouri turned the whole enterprise around. He looked at Bob and said, 'I think I can help you.'" It was a moment in which Staffanson saw that as much as he was reaching out to the Indians, they were seeing an opportunity, perhaps, to offer their teachings and wisdom to him, a representative of the non-Indian world.

In September 2007 I attended the Ancient Voices Forum on Haida Gwaii. I joined participants who came from around the continent—an anthropology professor and one of his students from Arizona, a school teacher from Colorado, clergy from Montana, a retired couple from Ohio, a philanthropist from San Francisco. It had been almost twenty years since the Circle of Elders first came to Haida Gwaii. The effects of the cultural renewal were everywhere. A new Heritage Centre, where we met, was opening. Several cedar canoes were being carved in the massive workshop there. The repatriation of ancestral bones was almost complete. Young people performed traditional songs and dances.

The islands, off the coast of British Columbia and just south of Alaska, hum with power generated by the interaction of open ocean and rugged land. Haida Gwaii is dominated by the effects of the Pacific. It is a mountainous, cloud-shrouded land creased with channels and islands and inlets, home to diverse animal life, and to a storied tradition of Haida culture running back many generations.

Elders from throughout North America came to the forum to share their stories and collective wisdom. I had learned enough about the institute to appreciate its mission and to accept the power of its impact on people, at least theoretically. What I didn't expect was to find myself changed by the experience, perhaps much as Bob Staffanson had been changed by his days in the Blood Indian Medicine Camp, four decades earlier.

Each day began with a traditional morning ceremony, held around a fire on the steep, gravel beach overlooking the ocean in front of the Heritage Centre. Bald eagles coasted by as we clustered, a group of strangers, around the fire that had been started before dawn. Ravens landed on the tops of totem poles. The sense of the place, and of the people of that place, pervaded everything like the salt in the sea air.

"I don't know what it is," said Noyes, "but the fire ceremony opens people up. It goes right inside and gets people speaking from the heart."

Through the days elders also spoke formally to the group about their beliefs and traditions. They shared

their stories, some poignant and wrenching, others humorous. For one entire morning session an elder simply gave thanks—to the sun that rises every day, to the wind and water, to the night, to the birds and animals that live amongst us. His words were extremely simple and, in a way, repetitive. They were also utterly moving. Another morning a Mohawk elder remembered his father and grandfather, who had been pulled out of their families as four-year-old boys and sent to the Carlisle Indian School. They didn't return until they were in their twenties. That experience had scarred them for life, made them incapable of ever showing emotion again. He said he was breaking that cycle by holding his children and grandchildren close.

The basic pragmatism Staffanson refers to came home several times. An elder from Greenland, nicknamed "Uncle," who travels widely to conduct healing ceremonies and spread the word about climate change, remembered an event in New York City.

"It was very hot," he said. "After the session I was so hot I suggested we all go for a swim in the Hudson River. I started running toward the water, but people called me back. They told me it was dangerous to swim, that the river was too polluted."

He turned to them, incredulous. "I just read a newspaper story," he said, "that ranked New York as the most highly educated population of any city in the world. You are the most educated people on the planet, and yet you pollute your own river to the point you can't swim in it? I don't understand."

The second morning at the forum the Haida brought a guest to the dawn fire. He was a young man who had reintroduced many of the ancient songs, and created new ones. He stood outside the circle during the lengthy ceremony. Near the end he was brought forward.

He began to openly cry. "You have no idea how much this means to me," he said. "To be at this fire, to feel the real emotions. I can't tell you how incredibly hard it is to stay on the path, to resist everything. The drugs, the alcohol, the things to buy, the video games. All of it. It is just so hard, every day, to stay true. Thank you."

As he spoke I felt the barriers melt away. I realized that I had been attending this as an outsider, looking in at indigenous culture, but essentially remaining separate. Yet, as this young man spoke, and bared his emotions, it struck home that there is no separation, that what he spoke of is true for all of us. It is terribly difficult for all of us to stay on the path, or even to find the path.

What he said was true for me. He was speaking directly to me, about my habits, my addictions, my seduction by consumerism. What he identified is the current human condition, not an Indian problem. It made me think of a candle flame flickering in a wind.

I looked around the circle, at white people, Indians, each of us with our burdens and struggles. I don't remember making a conscious decision right then, but the truth is that I haven't touched a drop of alcohol

since. And many times in the months since, particularly when I am tempted to pick up a drink, Bob Staffanson's words echo in my thoughts.

"We are stimulating this energy," he said. "And it has a way of spreading."

While Staffanson champions a vision full of hope, and while his efforts have had an undeniable effect, he is skeptical about non-Indian culture being able to adjust and change in time. "The chasm is just too great," he says.

"It's not the Earth we need to worry about," adds Noyes. "The Earth will survive, it will go on. It's us we should worry about."

"There are people from each circle, Indian and non-Indian, who think the circles will come together as one in our time," Staffanson admits. "I don't believe that will happen, but there are an increasing number of people who can see with two pairs of eyes. That is encouraging."

As was true in 1977 at the first gathering, Staffanson has no idea how things will keep evolving over the next generation and beyond.

Only four elders from the original circle are still alive and actively engaged. Joe Medicine Crow is one. He is elderly, frail, and almost deaf. He was raised by his grandparents who were from the pre-reservation, pre-literate era. One of his grandparents worked as a scout for the U.S. Calvary. Younger traditional Crow leaders are now stepping into the circle to carry the work forward.

"I do know this," concludes Staffanson. "I know it will continue. I know the Circle will be here. There has never been any real doubt about that. I can't say anything about the specifics, but I know the energy will survive and go forward. It's a procession, and it keeps being fed, keeps being strong. 🖋

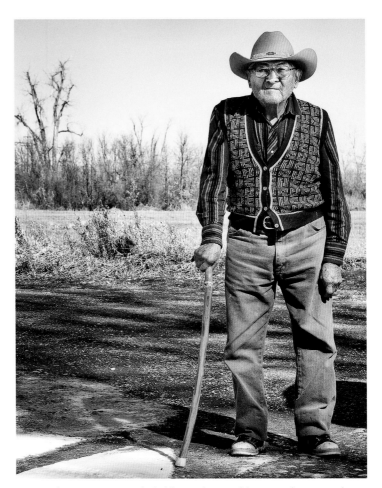

Joe Medicine Crow, a tribal elder and a World War II hero, stands outside his home in Lodge Grass.

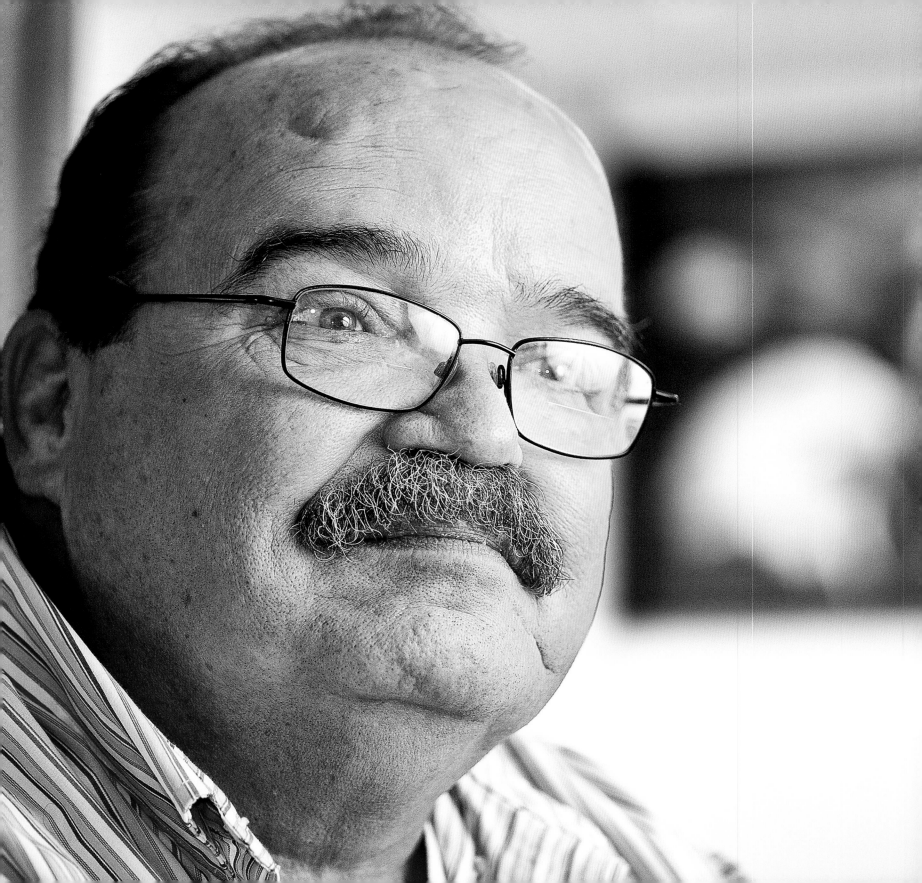

Redemption

Richard Stewart didn't know what drew him to the juniper tree, but he found himself sitting next to it on the rocky ground. He discovered it soon after he'd moved in to the farmhouse rental he'd landed outside of Bozeman. One afternoon he left the clutter of his unpacking and walked along the ridge to the south, exploring, settling, trying to find his bearings. Maybe half a mile from the house he noticed the tree and went to it. He found a comfortable seat in the meager shade, took in the view of the Bridger Range and the Gallatin Valley. It was soothing there, quiet and spacious, undemanding. The clamor in his mind, that roil of doubt and fear and hope, quieted down. In its place, a peacefulness welled up inside.

He found himself returning over the weeks, pulled back to that same unremarkable, but beckoning tree. He went when he felt overwhelmed and unsure, when the flames of fear roared up in their consuming fury. It was his sanctuary, a source of strength. The tree grew out of barren, rocky ground where the soil was thin. The roots were gnarled and twisted, groping for purchase in the unforgiving bedrock. He saw where the roots had actually broken the rock open. The bark was furry with age, the trunk scarred and cracked,

After spending much of his life in prison, Richard Stewart has found himself through art.

branches bent by winds and blizzards. The tree had persisted, and even flourished, against odds, decade after decade, making do with its meager allotment, growing old and strong and firmly rooted in spite of conditions.

The third or fourth visit, it dawned on Stewart that he was that tree.

How he came to be sitting by it is a tale as tortured and remarkable as the roots that manage to pull life out of fractured rock.

Stewart doesn't like to dwell on what he calls "the bad stuff" in his sixty-two-year story. What matters to him is what came after the decades of marginal, desperate existence, what came after that saga of survival that lasted most of his life. And he's right. His triumph

over darkness and squalor is what matters. And yet, to appreciate the life he has achieved requires the telling of what came before.

To the extent that the fickle, chance circumstances of existence shape our destiny, Rich Stewart drew a very short straw. It was his lot to grow up in a broken family terrorized by generations of predatory pedophiles. Stewart was victimized by his older brother. He never met his father. His mother either couldn't cope or contributed to the family dysfunction. Home was a circle of hell, hidden from view, but all the more depraved for that. Starting at the age of eight, Stewart was farmed out to foster homes, some of which were as brutalizing as the one he fled. By the time Stewart was eleven years old, he'd escaped to the streets of southern California.

Escape, perhaps, but certainly no reprieve. "I was very shy," Stewart remembers. "Hollywood and Long Beach, where the homeless congregate and where I ended up, is no place for kids." Stewart was repeatedly taken advantage of by sexual predators. "I got so I couldn't stand people touching me," he says. As an object of prey, he lived in a constant state of fear and brute survival.

Stewart endured suicidal periods. He was convicted of assault with a deadly weapon, tried as an adult, and served time. As he grew older, stronger and more street savvy, he learned how to protect himself, even how to turn the tables on the predators. The down-ward spiral, however, a descent that began for Stewart at birth, pulled him into its inexorable vortex. Out of jail, he took off north for Canada, where he stole a car, got caught and was deported to spend more time in custody.

"By then I'd learned that the bigger and uglier you got, the better your chances of survival," he says. "Back then, all this," he points to his generous belly, "was up here." He indicates his shoulders. Stewart had learned to ambush the pedophiles who had haunted him all his life. He'd play out the scenario, let himself be led off, and then beat the hell out of his tormentor and steal him blind. All the while, he convinced himself that he was getting back at his brother.

"At the same time, even in the middle of all that," he says, "I always knew that this wasn't what life was supposed to be. Somewhere I knew that this wasn't truly me."

In 1976 it came to a head. Stewart was fleeing north again, running from his tormented life in southern California, hoping that a change in place might lead somewhere different, anywhere different.

"Almost made it," he says, ruefully. But in northern Montana, at a bar in Olney, outside of Kalispell, Stewart got in a fight with another man. By then he had been in a great many fights. Fighting was how you

survived. But this time he killed his opponent.

Stewart ran. He kept running. He ran for eighteen months. And all that time he was pursued by Montana Undersheriff, Dutch Taylor.

Stewart landed for a time in New Orleans. He worked as a bouncer in bars, served drinks, always looking over his shoulder, ready to bolt. And it was in New Orleans that Stewart began to dabble in art.

"I remember walking around in Jackson Square," he says. "There were all these street artists doing portraits." Something spurred Stewart to try it. He began sketching faces. He was shy about it, but people liked what he did. For the first time, Stewart had a glimmer of something positive, something he could produce that people appreciated.

"Art was something I could do," he says. "I got praised for it. I was accepted. I'd never had that before."

But he remained a fugitive. "I managed to stay free," Stewart says, with a shrug. "I even fell in love. But it was really hard to keep it up."

Finally, outside a gambling casino in Las Vegas, where Stewart was making a marginal living playing the tables, he succumbed to impulse and turned himself in. He pleaded guilty to murder and was sent to Deer Lodge. At the time, Montana was looking to reinstate the death penalty. Stewart volunteered to be the test case. He saw no reason to go on.

"I deserved it," he says, simply.

And then, something strange; a random circumstance that pivots a life. For Stewart, his resurrection began out of the quirky fact that in Montana, when his case was heard, the death sentence was meted out at the end of a rope. Stewart had no idea that when he had volunteered to die, his life would end with a rope around his neck.

In his many years in prisons, Stewart had found men hanging in their cells five times. Five times he had held them up, slacking the pressure, feeling the dead weight limp in his strong arms, hoping he wasn't too late. Three of those men survived, but the impression of these dangling bodies, the visceral horror of it, had seared itself indelibly in Stewart's memory. He couldn't countenance the fact that his life, wasted as it had been, would come to that same end.

The night before his sentencing hearing, Stewart prayed for the first time. He had flirted with religion before, but in his mind, this was the first time he truly, whole-heartedly, offered himself up.

"I was literally brought to my knees," Stewart remembers.

He put a blanket over his head to block out the ever-present cacophony of prison. He prayed. He felt something he'd never felt before. A presence. A stillness. Everything went quiet. Held in that moment,

Stewart made a vow. If I don't hang, he promised, I will find out about you.

But the next morning his hearing went ahead as scheduled. Stewart was brought into the courtroom in handcuffs. The judge asked the state for its recommendation. The state's attorney didn't answer at first. The judge asked again. Again the attorney was silent. The third time he asked, the judge brought down the gavel so hard it rang through the room like a pistol shot. Finally the state's attorney brought up his head. In a quiet voice, he announced that the state had decided to withdraw its request for the death penalty. How that came to pass Stewart never found out, but it was that moment, and the prayerful interlude in his cell the night before, that changed the trajectory of his life.

Stewart was still serving time. Because he was classified as a dangerous offender, his sentence was 100 years. Even so, everything else changed. Stewart made good on his promise. He read the bible, attended services, found out about the God he had prayed to.

Dutch Taylor, who hunted Stewart all those months, had recognized something in his fugitive. He knew Stewart's rap sheet, where he had come from, the hand of fate he'd been dealt. He also knew that Stewart had a knack for art. He believed, in some intangible way, that Stewart was capable of rising out of his circumstances. He kept in touch, gave Stewart his card, told him that if he ever needed anything, to give him a call. At the time, Stewart had thought nothing of it.

But prison slowly drove Stewart crazy. Months passed. He remembered Taylor's offer. He had nothing to lose. Not expecting much, he made the call, and Taylor came through. He brought him art supplies, paints and canvas and brushes. He encouraged him. Taylor became Stewart's first real mentor.

Stewart's cell was illuminated by a single 60-watt bulb. He taped that first square of canvas to the concrete wall, sat backwards on his toilet seat, and did his first painting. He painted an elk. He painted quickly. His cell was cramped and uncomfortable. But when he showed his fellow inmates, they were impressed, encouraged him to do more.

"That acceptance spurred me on," Stewart says. "Through my art, they were telling me that I was worth something."

Stewart began to get involved in self-help groups at the prison. He volunteered to facilitate mental health groups and initiated discussion circles. Bit by bit, the life he had come to the brink of giving up began to make some sense. The light of hope, even salvation, flickered in the darkness.

"I was finding ways to put a stick in the spokes of those destructive cycles," Stewart says.

More and more, he found solace in his painting. Eventually the prison gave him access to a studio. He would paint animals from pictures, self-portraits, faces,

mountain scenes. He found himself pulled utterly into his subjects. "It's funny," he says, "but there were times I could have sworn I just heard a bird call in the scene I was painting."

Changed or not, the fact remained that Stewart's sentence was stuck at 100 years by virtue of his classification—a dangerous offender. After serving ten years, Stewart appealed his sentence, arguing that he no longer fit that description, demonstrating the changes he'd gone through and the activities he was involved in. The court agreed and changed him to a non-dangerous status, a move that allowed the possibility of parole after twenty-five years. In the end, Stewart served twenty-nine years. Combined with his earlier jail time, he had been incarcerated for all but three years between the ages of eleven and fifty-two.

"I truly regret the things I did," admits Stewart. "The fact is, if I hadn't gone to prison, there's no telling what I would have turned into. Prison taught me about struggle, and about life. Before that, it was nothing beyond protecting myself, surviving to the next day."

Stewart was set free, but life on the outside was terrifying. As a prisoner, everything is scheduled for you—when to sleep, when to go outside, when to eat, when to shower. Year after year, it turns people into zombies. Stewart had never had a bank account, didn't know how to get a job, hadn't ever rented an apartment or cooked his own food. On a fundamental level, he didn't know how to interact with people.

"There were days I would have gone back to the comfort and security of prison in a heartbeat," he says, laughing.

Stewart was fortunate. After his release, he was met in Bozeman by a group of mentors—volunteers who helped him deal with the logistics of life, listened to his fears and challenges, introduced him to opportunities, found him places to live. Simple, practical gestures without which ex-convicts more often than not flounder, or revert to old habits.

As important as the day-to-day assistance, Stewart also found ways to slowly give away his hate and anger, the drive for revenge that had simmered in his bones with the memories of his brother's tyranny. "I can't even be angry at my brother anymore," he says.

"It sounds silly," he says, "but realizing that I could make choices was huge. I could choose to turn away from the negative things. That was as liberating as walking out the prison door."

In nearly a decade since his release, Stewart has reinvented himself, and the change is astonishing. But it has not been easy. Even with the benefit of mentors, his spiritual base, and his artistic talent, it continues to be a struggle. He has endured a battery of health problems, including diabetes, a heart attack, a hepatitis

C infection, chronic back pain and asthma. Money is always an issue. Stewart exists on disability payments and his art sales, many of which are barter arrangements, or word of mouth transactions. While his paintings have been showcased in several galleries, including pieces in Jackson Hole's West Lives On, and in Bozeman's Montana Trails Gallery, "just in time for it to blow up" in a gas explosion, Stewart doesn't have much tolerance for the "hype" of the commercialized art world.

And there are the inevitable old patterns that loom at the edges of vision, temptations in moments of weakness. He finds his bearings in reading the Bible, in painting, and in the people who offer friendship; people like Clyde Aspevig, who comes over occasionally to paint with Stewart and provide artistic advice.

Part of Stewart's reinvention of self has also come through paying it forward. He mentors other men making the transition between prison and the street. Over the years, he has taken in eight roommates who have been navigating that perilous passage. He volunteers at church.

"Grace," he says, when asked what has allowed him to make his transformation. "Without that, and everything it made possible, I never could have made it. Grace and art. Art has changed my life," he stresses. "It brought me acceptance, it brought me a social life. It meets my needs, gives me a focus, and it keeps me humble."

Stewart begins each day reading the Bible, sitting in his small living room as the sun rises over the Bridgers. Then he paints. Craggy mountain scenes with mist tearing against cliff bands. Teepees set in the foreground of a riverside cottonwood grove. A trio of raptor heads—Strength, Faith, and Rage. The purl of river gliding through a tight canyon, with the water absolutely transparent, and a trout hanging in the current between boulders. A pair of bull elk charged with rut, squaring off in a meadow. The ancient, furrowed face of an Indian elder. For hours he is pulled in to the challenge of rippling water, the curve of an elk's neck, the last fall colors in a tree, how to get it right. He loses himself—his past, his decades of gritty survival, his remarkable catharsis, how a single life can embrace such extremes.

Then, maybe, if the afternoon is warm and his bodily aches allow, Stewart might go out the door and turn south, walking slowly down the barren ridge away from the road, to sit in the company of his enduring juniper, that tree that is him—gnarled with life, triumphant in spite of everything, offering shade and quiet and strength. Time recedes, the desperation that always lurks at the edge of existence fades away. Richard Stewart lets it go, he takes in the view of half the county, a view that no one else over these many years has stopped to drink in. 🄰

Stewart says he draws inspiration from the environment around his home west of Bozeman.